DEMOLISHED
HOUSES
OF SYDNEY

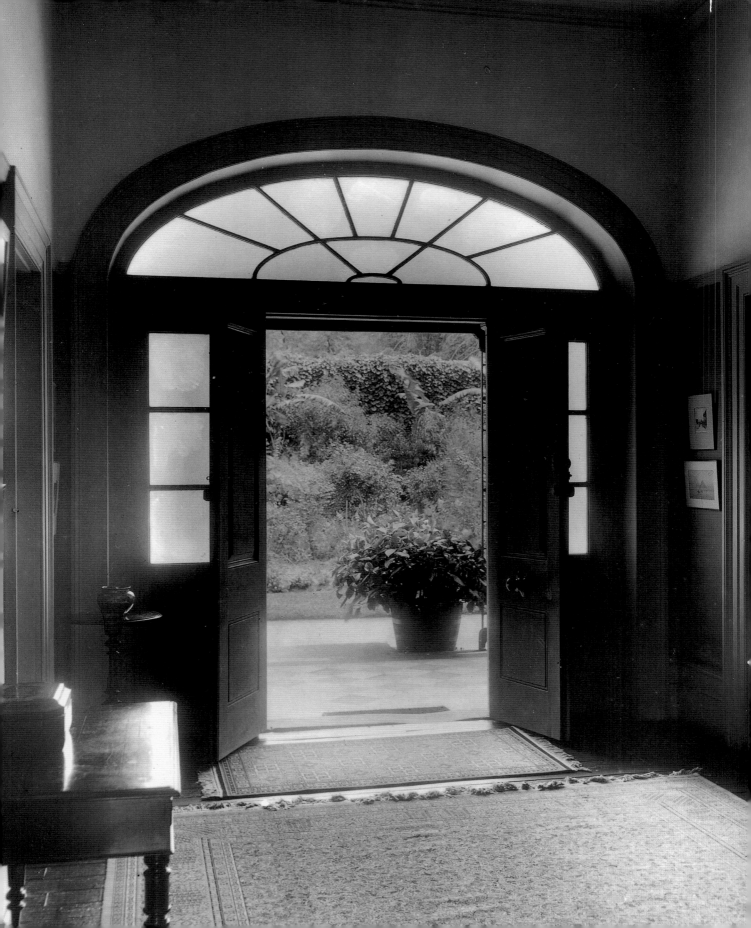

HISTORIC HOUSES TRUST OF NEW SOUTH WALES

DEMOLISHED HOUSES OF SYDNEY

Edited by Joy Hughes

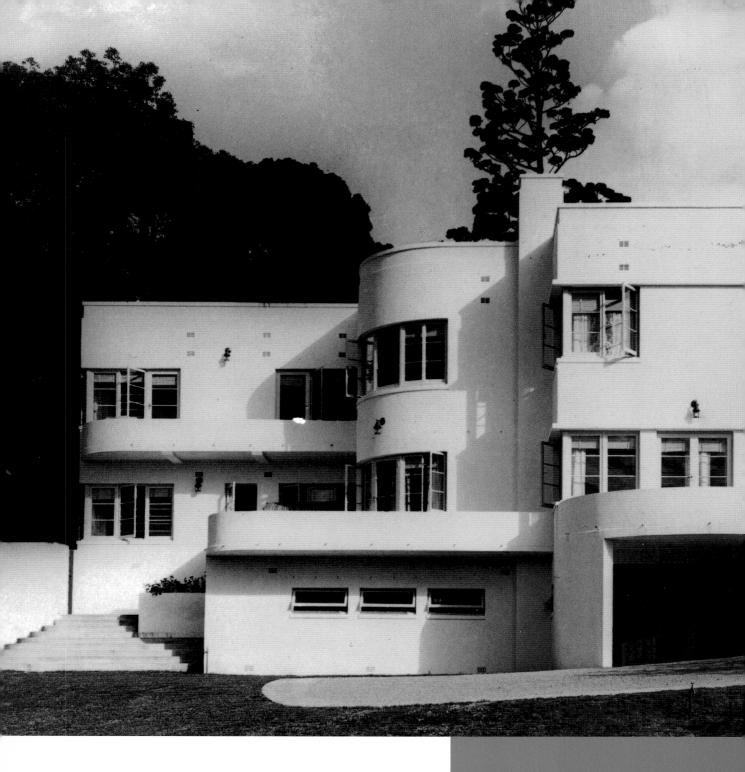

*Cotway, Bellevue Hill, designed in the 1930s by
F. Glynn Gilling for the Field family. Demolished in
1990. Photograph Cecil Bostock, from the
collection of Douglas Gilling*

*Frontispiece: Entrance hall, St Malo, Hunters Hill.
Built c.1856; demolished in 1961. Photograph
Harold Cazneaux; Mitchell Library, SLNSW*

CONTENTS

INTRODUCTION

FOREWORD

Take any one of the major roads out of the city – north, south, east or west – a block of home units or a row of townhouses usually signals the site of a demolished house – thousands of houses have gone. How many more single cottages, streets of houses, even whole suburbs have been buried or mutilated by freeways or swept away by the tide of demolition to meet the growing demands of education, commerce and industry?

This publication takes you on a journey along these major roads to the extremities of our great metropolis – with the occasional side trip or two – and through a representative sample of Sydney's demolished houses shows what has gone and why. Not all of them will be missed. The houses – ranging from humble to grand – were built between 1788 and 1968 and demolished from 1845 to 1998. Some were the work of well-known architects. Others were architecturally unremarkable, but of historical or social significance to the local community. A number were good examples of their type and as such represent similar losses from other suburbs. And not many of the eponymous houses – those whose names were later adopted for a suburb, survive.

Joy Hughes
Historian

Greed. Greed and Sydney seem to go together. They come in many guises. The greed of the developer, the property owner, the car – and everything it demands, the 'old Sydney families' as well as the newcomers, and the 'new money'. It seems to be infectious – and built into the psyche of the place. It knows few boundaries. It leaves little room for nostalgia or niceties, for memory or modesty, for imagination, for gardens, or for neighbours and community. To hell with the public domain – its streetscapes, views, good architectural manners, appropriateness, and the public good. Instead we seem hell bent on maximising profit and views, showing off, building big – and brassy – and tearing down.

How many cities in the world could have offered what Sydney did? A temperate climate and a geography of unparalleled beauty and opportunity. Some of the best building sites imaginable. And we got it right. At least much of it was excellent until about the mid twentieth century. Not all of it was good. But a surprising amount of it was. Great city streets of consistently fine buildings. Suburbs and their houses that responded sensibly and sensitively to the climate and the landscape. Buildings that quietly and modestly took advantage of the opportunities that presented themselves.

There was lots of money from near the beginning. It made for marvellous houses. And the best sites were there for the taking. Refined neo-classical houses in Arcadian landscapes, grand Gothic villas in the most naturally picturesque settings imaginable, rows of terraces marching up and down hills, oversized and overstuffed mansions of the late nineteenth century grandees, suburbs filled with Federation houses with deep shaded verandahs and lush gardens. But these places were also assets. Assets to be realised. Sydney has always speculated with and exploited its land. It is the source of much of its wealth. Acquisition,

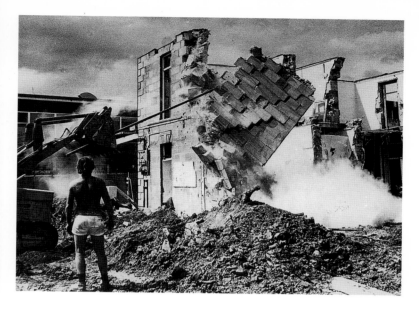

demolition, subdivision, redevelopment. Building up and tearing down – over and over again. It's a relatively easy path to wealth. Start with your own house. Then move on to bigger things. No wonder that the stock of domestic buildings has received such a battering. Perhaps it is inevitable in such a relatively young city. Perhaps the trouble is we just kept getting richer. Was that the problem? Too much money, too much greed. A race to remove the old to replace it with something bigger and better. Trouble is it was often not better than what it replaced.

Certainly there is a raw energy about Sydney that can be very seductive. But can we use this to excuse the worst excesses? There needs to be a balance between the manifestations of Sydney's wonderful energy and vitality and the retention of those places that represent the collective memory that all civilised cities need. If there is any doubt that the balance is wrong then visit central Parramatta, or almost any street on the lower North Shore that affords Harbour views. Or look through these pages and ponder what has gone. And what has replaced it. Reflect also, on the relatively recent losses of many of the houses that appear in these pages. Surely there must have been ways, at least in some instances, where the creativity, energy and re-sources that created these special places could have been retained and remodelled into something useful and viable for their owners and for the community.

Much of what was lost followed long and loud struggles for its retention. It was not as if there was no-one who cared. But all too often their pleas went unheeded. And we continue, far too often still, to ignore these voices.

In 1988 the Historic Houses Trust presented the exhibition and book *Demolished for the Public Good – Crimes Follies and Misfortunes*. It was a catalogue of houses from throughout New South Wales that have been lost, and some that were threatened. It was written and curated by James Broadbent and Joy Hughes. This follow-up exhibition focuses exclusively on Sydney. It is the work of Joy Hughes and to her I am most grateful for her extensive research, for the breadth of places she has chosen to include and for the social history she has injected into her task. Her years of scholarly work for the Trust, and for others, shines through. The Historic Houses Trust is grateful, too, for the access it has had to the extensive photographic archives of the National Trust of Australia (NSW), the Mitchell Library, State Library of New South Wales, and the Royal Australian Historical Society.

The foreword I wrote for the first exhibition in 1988 was cautionary. This is angrier. It deserves to be. It will, I am certain, reflect what many others feel.

Peter Watts
Director
Historic Houses Trust of New South Wales

Ormonde, Penrith, built in the 1880s, demolished 1979. Photograph John Fairfax Ltd

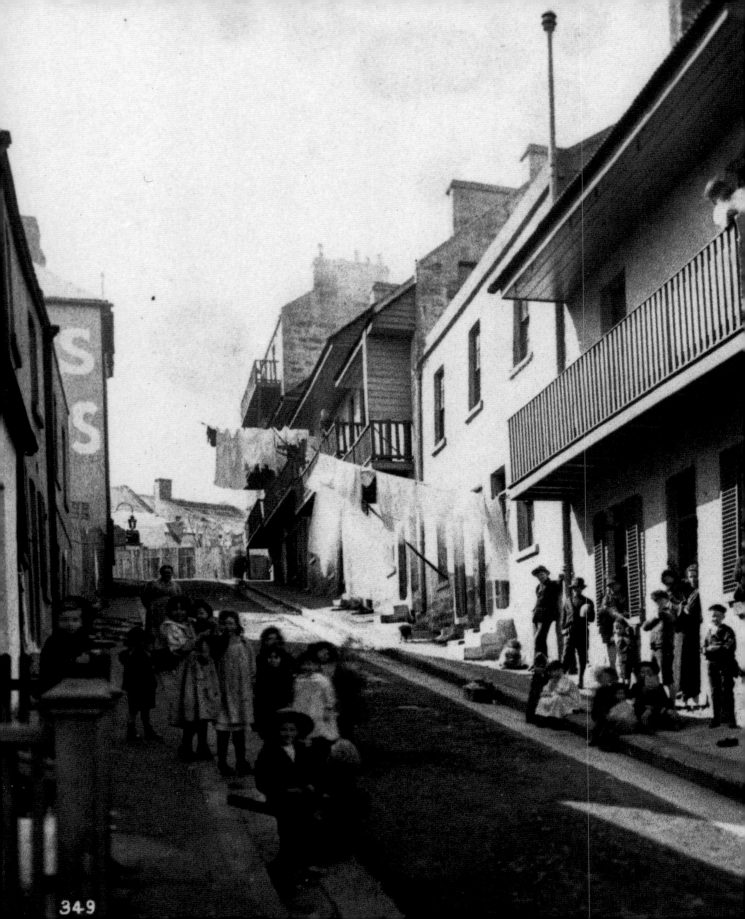

SO DO WE CARE?

In my professional work I think about Sydney every day. In between times I live in it. Sydney, backdrop and full set. A very complex set.

I grew up in Adelaide. I always think of Adelaide, with its ordered grid, its wide streets and its generous building blocks as a city of houses. And of Sydney as a place where houses struggle to gain a foothold, struggle to compete for space. Partly it's the terrain – up and down, building around the edges of things, around endless wondrous harbour foreshores and river inlets. Hacking into rock-faces, quarrying down, building up. Then there's the competition from industry that during the nineteenth century and half of the twentieth insisted on the best sites close to the original settlement. Here there is no Port Adelaide or Port Melbourne, a civilised distance from town. Sydney the port, the industrial town, the city, all of it tumbled together, all clawing precious pieces of land from each other. And in the uneven struggle with industry or commerce or transport it is usually the houses that lose out.

Here in Sydney we've been pulling down houses from the very beginnings of European settlement. Early government edicts announced that anyone caught throwing rubbish into the Tank Stream or gutting their fish in it or doing their washing in it ran the risk of a conviction which involved having their house pulled down and paying a fine to the Orphan Fund (*Sydney Gazette*, 18.12.1803). In 1807 Governor Bligh ordered the demolition of a number of houses which had been built 'adjacent to Government House, to its great annoyance' (*Sydney Gazette*, 2.8.1807). The image of an imperious government residence choosing to be annoyed at the tone set by its lesser neighbours is topped of course by the subsequent unceremonious demolition of Government House itself. One of the earliest 'permanent' structures built in the town, it was pulled down in 1845 and the Bridge Street site given over to a brick storage yard. Nobody cared much. But such a place would be remembered, and details recorded in illustrations and in the written record. Eventually a plaque would be struck, concerns would be raised and in the end a museum would mark the spot.

No such records exist for most houses and very little is known about those which disappeared in the first half of the nineteenth century. Except that they did go. Practically every house in the inner, oldest streets was demolished and replaced with grander houses, with shops, factories and solid commercial buildings. In place of a Georgian town we got a Victorian city. But it was still a city full of houses, as the image of Phillip Street in 1871 indicates. This Victorian city was photographed, recorded in rate books and reported on at length by newspapermen and so it is easier to know what we have lost.

In the twentieth century most of that city's housing went the way of the earlier lot. Industrial activities were banished by legislation or by rising land values, and along with them went the workers' cottages that surrounded them. A few of the more substantial houses made it into the twentieth century but hardly any have made it through to the century's end. Today we just thoughtlessly refer to the original town as the CBD.

Beyond these central streets survival rates were better. But often not much better.

Take the example of Pyrmont and Ultimo. At the 1891 census about 19,000 people lived there. That was its heyday. For houses, that is. From then on

they just kept disappearing until by the early 1980s the population had bottomed out at around 1500. In this one small area most of the forces which could possibly operate to devour housing stock were present.

The most obvious was industry. Woolstores, quarries, powerhouses, freezing works, flour mills, warehouses and workshops spread relentlessly across the landscape. Down at the Pyrmont end of the peninsula, the Colonial Sugar Refinery, originally built in isolation but long since hemmed in, kept on chomping up whole streets of houses as it had been doing since it first purchased Chowne Street way back in 1893. The company did not just demolish. It also built housing, and it leased subsidised 'tied' housing to some of its employees. But any house owned by the company was liable to disappear if the industry required the space. Demolitions in John, Jones, New and Bowman Streets in the 1970s tore at the heart of the community and when Smooges Terrace was pulled down in 1981 there was local outrage. This row of large semi-detached houses gave the place some tone, the locals thought. After all they were classified by the National Trust – something which didn't happen to many houses in Pyrmont. But when they came down, people were not just angry at the loss of some fine houses. They were devastated when it turned out to have been done for just another car park.

There were ever-increasing requirements of land for transport services. Rose Cottage, built around 1840, was demolished for a new railway line in 1916, just one of many houses on the peninsula that went to make way for transport infrastructure. In the nineteenth century it was railways and railway goods yards. Then in the early twentieth century it was wharf redevelopment. By the 1960s it was massive freeways that were planned to go west and south-west into the suburbs, cutting great swathes through Ultimo. Not all of this came to pass. Some of the plans were stopped through resident outrage, union bans and a change of government. But people's futures were made uncertain for years as houses became 'DMR affected', and the end result is a spaghetti bowl full of roadways which pass from Darling Harbour across and over and under a decimated Ultimo.

The third factor operating to destroy houses was the expansion of educational institutions. Ultimo House, built for John Harris, the original grantee, in 1804, was demolished for the sake of education. The original Sydney Technical College was built in Harris Street in 1893, and by 1910 the site was doubled through expansion into the area which included Ultimo House. This remnant of old rural Ultimo was progressively hemmed in by college buildings. Nobody cared much about its connections to the early convict architect Francis Greenway or its links with the political intrigue that culminated in the Rum Rebellion, and eventually it was pulled down in the 1930s. So too were dozens of lesser houses. Or was it hundreds?

The story of the Pyrmont peninsula is repeated over and over in other places. Education, transport and industry all conspiring to demolish houses. Only the degree of rapaciousness varies.

Variants of the Ultimo House story are commonplace in this town. Educational institutions often begin with an erstwhile grand house as nucleus. The gardens are sacrificed for more school buildings, surrounding housing is bought up, and eventually the old landmark building is pulled down. One of the surprises to me in contemplating any list of demolished houses is to see how often this story of educational expansion occurred. Royle House (Yandooya) and Cotway, Bellevue Hill; Athole, Thomas Street, Parramatta; Crows Nest House; Chislehurst, Centennial Avenue, Chatswood; Kamilaroi, Windsor Street, Richmond; Kenilworth, Penshurst Street, Penshurst. Just some of the demolitions for school expansion. What kind of lesson does this teach?

The schools' story is magnified a hundred-fold in the case of the largest educational institution of them all. The University of Sydney is proud of its own fine pile of sandstone buildings, constructed in the 1850s from sandstone gouged out of Pyrmont. The buildings stood in splendid isolation on the Grose Farm just outside the city limits. But the reality of the expansion of tertiary education since World War II has meant the destruction of a great deal of housing surrounding the old university property in recent decades. Almost the whole of the little suburb of Darlington just disappeared. There are the remnants of some sandstone kerbing, a horse trough and a little school retained within the university boundaries, but the housing has long since gone.

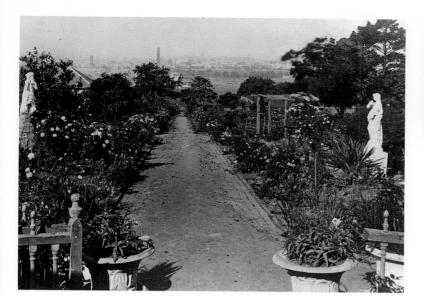

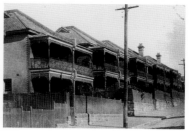

This kind of destruction happens slowly by accretion. Eventually memories fade and the imagination fails. Ask any student of the University of Sydney how often they contemplate the significance of the destruction of Darlington.

Demolition for transport needs can be more brutally obvious. When housing is demolished for a road or a railway or a bridge, the lines it leaves on the landscape can be a more permanent reminder of what may have been there before. As it is in Pyrmont and Ultimo. In the great scar of a freeway it is easier to imagine the past underlying community, now gone.

But the full story of the triumph of roadways over houses has involved a great deal of smaller scale destruction as well. Unlike Adelaide or Melbourne with their wide streets, Sydney has had to claw back street space from rows of houses that lined narrow thoroughfares evolved in a less congested era. The early decades of the twentieth century saw a flurry of 'improvement' as areas considered to be slums were cleared and streets were widened. The term used for it was 'remodelling'. The work of the Sydney Harbour Trust in demolishing parts of The Rocks and Millers Point in order to upgrade the port facilities and to clear the path for approaches to a harbour bridge was the most dramatic example. But the City Council carried out dozens of smaller clearances as well, and narrow streets were widened by knocking down the houses along the entirety of one side

George Street West (Broadway), Park Street, William Street, Oxford Street and so on and on into smaller side streets, sometimes removing older street patterns and older 'rookeries' of houses altogether. A new road was put through Surry Hills to improve access to the new Central railway station which itself had led to demolitions.

Then there is the need to park the cars. The cheapest way to do this has often been through demolition of houses. If there is some rule of thumb which claims that a demolition is acceptable if the replacement is better in some way, or more necessary, then there is nothing more likely to anger readers of this publication than the caption 'demolished for a car park'. Demolitions for expressways are often controversial and generate widespread community debate, but nine times out of ten, demolition for a car park is vandalism of the most short-sighted kind. As it was with Smooges Terraces.

The story of the inner areas is repeated with variations, in ripples of ever-increasing circumference as Sydney grew. Train lines snaked westward, and then south and north and once isolated farming properties became subdivisions for housing. The older houses were eventually demolished. The first to go were the ordinary farm workers' cottages while the larger houses often hung on, often bequeathing their names to the new suburbs. But as the suburbs grew, the old landmark buildings would become ever more encircled and encroached upon. Gardens and vistas

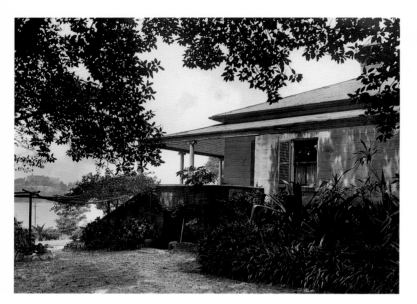

would disappear and sooner or later the houses themselves would be demolished – Annandale, Waverley, Pymble's house – the list goes on.

The best new housing was located close to the railway stations, with smaller cottages a little further distant. Once omnibuses began to service the stations, housing could wander further afield, and with the introduction of tramways from the 1880s the areas in between began to infill. And again, the same forces which attracted housing also appealed to industrialists. Proximity to the railway station was good for a flour mill to take delivery of its mountains of grain, while locations on the Parramatta River suited industries such as timber milling that used barges as transport, or chemical plants that found the river a convenient sink for their pollutants.

The location of industry is the least permanent of land uses, and the relationship between industry and housing is the most complicated story to tell. Sometimes isolated industrial sites end up surrounded by housing and eventually the housing does win as de-industrialisation and relocation occur. Returning to the story of Pyrmont we can see that today industry has all but fled, and the peninsular is currently reinventing itself as a residential place. Not one of houses, but of new apartments, preferably with harbour views. These will provide for a greater population than at any previous time. (This kind of development, incidentally creates a new set of issues concerning the value of retaining our industrial heritage and maintaining diverse places

which are more interesting than ones which are saturated with modern apartments and pleasant landscaping can ever be. But that is a different essay.)

But for all the demolitions, resulting from industrial, commercial and transport expansion, there are many more which are simply cases of houses being replaced by housing … 'demolished for residential subdivision'… for 'high rise flats'… 'for home units'…

So do we care? The city has grown from a few thousand to many millions. Didn't we want those schools and fire stations and shops and all the other things? Minus the freeways, perhaps. Even freeways produce bridges, and don't we enjoy the sweep of the Gladesville Bridge and Fig Tree Bridge more than we mourn the passing of St Malo, demolished to make way for the road in between them? Isn't all this just inevitable? Isn't it progress?

In some cases the answer is 'yes'. Houses come and go, along with all life. A lot of mid-nineteenth century Sydney housing was so awful that nobody would wish it on their enemy. Like the row of houses in Chippendale, later remembered as having been erected on 'a sort of dog kennel plan'. Some of them fell over under the influence of heavy rain, others from 'sheer decay'. And they weren't even old. Just meanly built and happily eradicated. Report after official report listed such places. If any of these 'rookeries' had survived until today we might argue that keeping a little for educative

purposes would be a good idea, but that would be as far as most of us would want to go.

Then there were the houses that were not disgraceful, but that were replaced by something so much better that we never think to miss them. Bridge Street today is one of the fine colonial streets of commercial and administrative Sydney. Given the choice, most Sydneysiders would prefer these solid Victorian monuments in sandstone to the older generations of houses which gave way for their construction.

But what about some of the fine houses? It is impossible to contemplate the destruction of places like Cliffbrook or Subiaco without feeling anger as well as nostalgia. And what about the ones that represent rare examples of certain architects' work? Or the ones that were associated with people the community held in esteem, like Clovelly at Watsons Bay that housed a raft of well-known people. Or that weatherboard house in Brancourt Avenue, Bankstown which was the scene of a police shoot-out and evictions in the depression of the 1930s. Didn't it tell an important story? And talking of the 1930s, what about Jack Lang's house in Auburn? An ordinary house, but an extraordinary man.

And do we really think Sydney is the richer for doing away with residential Macquarie Street? Or Tara, in Parramatta, replaced by a factory in the 1960s? Is it good that if we want to experience Georgian buildings, we have to go to Tasmania to do it? Did last year's demolition of Devaran enrich Kogarah? Or the demolition of Chatsworth, Mark II, at Potts Point, which is being demolished as this is being written? Individual developers may be richer as a result of all this destruction, but is Sydney?

Or are we too craven to argue that there is

more to making a great city than just maximising the economic profits of the few? If it does indeed maximise them. I have yet to see any so-called economic figures which adequately factor in the straight economic benefits of maintaining places which give the city meaning and historical depth, quite apart from any social and cultural benefits which would accrue.

The inescapable conclusion from considering the level of destruction in Sydney is that we have been too cavalier. What has replaced some of the houses represented here is about as awful as 'progress' can possibly get. And it does not take too much imagination to see that some of these places could have survived and been incorporated into new developments. The critics who say that we could have had those bridges *and* St Malo strike a chord with those who believe that a modern city can coexist with a respect for and a retention of enough of the past to create a place which is wonderful to live in. A place far, far better than the one we have now. Better because a people who retain a collective memory of past ways can negotiate current cities with more skills and more commitment than those who simply live on the surface, unable to recognise the richness of the layers of the palimpsest laid down by all the others who have lived, worked, loved and contributed to the creation of the place.

Critics of the so-called 'heritage industry' will tell you that we have kept as much as we need to. They will point to The Rocks – saved only by the determination of residents and unionists, but now everyone's favourite – or to Glebe or to bits and pieces of layered Sydney here and there, and they will say we have held on to quite enough. This book tells a different story.

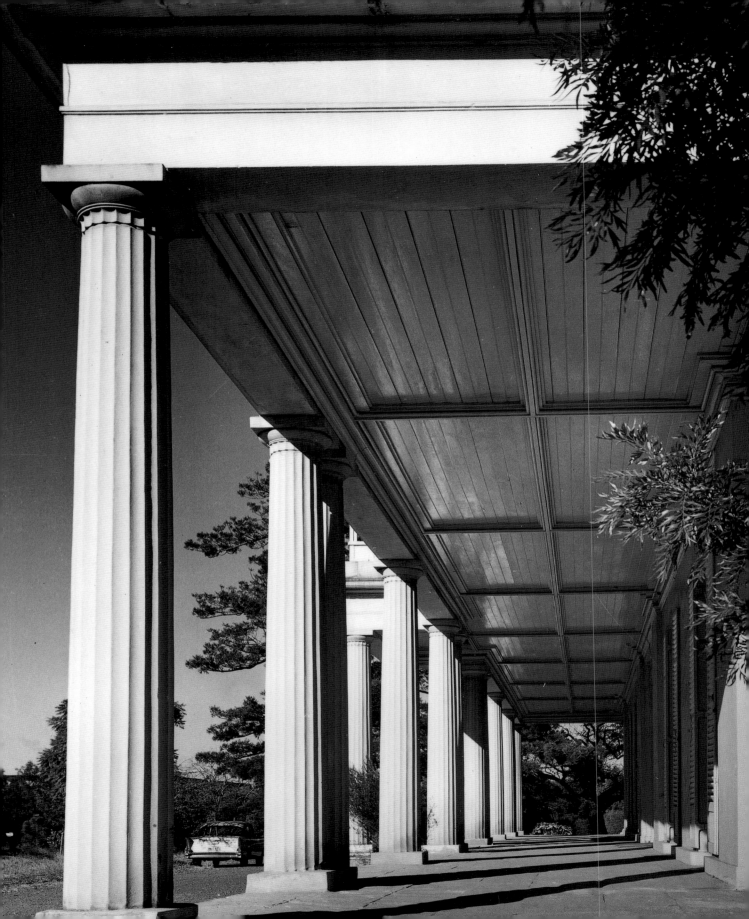

BEAUTY MAY NOT BE ENOUGH

Sydney has only itself to blame. Or so the argument goes. We wait until it's too late. We don't stir our stumps until the wreckers are in the streets and then we're too fickle to throw ourselves into the fight. The terrible losses over the years – streets, houses, whole suburbs, stretches of bush and coast – are really our fault because we let them happen.

That's such a useful old lie that Sydney has almost come to believe it. Subiaco? Only the blue rinse bothered. East Circular Quay? Too little. The Con? Too late.

The truth is that Sydney protests but Sydney doesn't listen. So many of the houses remembered here bit the dust after long campaigns waged to save them. Few came down unmourned. The noise of protest was as loud as the crash of falling timber – as loud and much longer. We always knew what was at stake. Photographers would gather on the eve of executions and lawyers kept petitioning the courts up until the last minute on behalf of the condemned. But those who might save the buildings were not listening. The guild of wreckers should have as its crest a politician with a plugged ear.

I saw these photographs of demolished Sydney first in the library at Lyndhurst, that elegant relic of the 1830s when Sydney was enjoying its first boom before the first great bust. Lyndhurst has intrigued me ever since the late 1960s when I lived around the corner in Glebe and moves were afoot to try to save the sorry pile from Bob Askin's next freeway. We were told – have I simplified the tale over the years? – that his new road must either flatten the house or the members' dining room at the dog track down below in Wentworth Park. So Lyndhurst had to go. What saved the house was another of those fine campaigns Sydney is told it never bothers mounting – noisy, informed, persistent – and the fact that a new premier came along who listened.

Not that Neville Wran was always a great listener. Remember Parramatta Park ...

One house was rescued. Lyndhurst is not a great work of art but who would argue now that it was not worth saving? It stands there refuting by its presence all the old arguments used to try to destroy it. Whenever we visit the handful of great private buildings saved by public agitation in this town, we should remember what was said to try to bring them down. Official brochures should list alongside the benefactors, the names of those who wanted the place demolished and a precis of their arguments: rot and decay too far gone, pressing need for the site, no cash to outbid the developer.

The arguments are fairly standard, now and a century ago, and why should they vary? They usually work. But our arguments in reply risk becoming just as routine. If we hope to stay ahead of the demolishers we need to look again at the reasons we fight to save buildings.

Do we fight for what's beautiful? Of course, that's instinctive. For history's sake? Yes, even to make sure the revisionists of each generation have the evidence they need. Do we do it for nostalgia? Nostalgia isn't contemptible but Sydney has a dangerous way of getting sentimental about any horror that's been around for 40 years. Good God, we've grown sentimental about the Cahill Expressway! Architects would probably muster these days to defend the monorail. So should we do it for tourism? Let this be the last card we play. If travellers want to look at this town, they should see the real thing, not some tourist's version of ourselves.

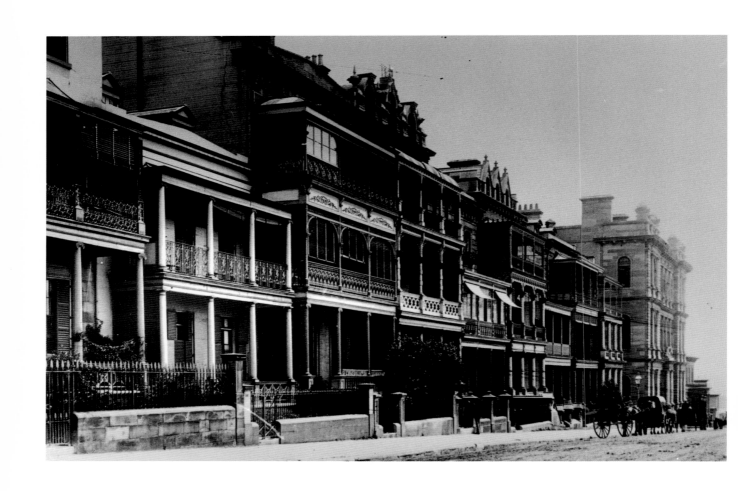

*Macquarie Street c.1900. Once the most
fashionable residential street in Sydney.
State Records Authority*

*Previous spread: Subiaco (formerly
Vineyard), Rydalmere, built in 1936,
demolished for a car park in 1961.
Photograph Max Dupain*

In truth, we need these old places for our imaginations' sake. Deep down in everyone is a hunger to have contact with imaginations from other cultures, other places and other times. This is why we read and travel, look at pictures, mix with strangers. Without access to other minds we stultify. Through buildings we reach other imaginations very directly, for buildings are both works of art and evidence of living – if and only if the buildings survive. Photographs are evidence of a sort and we're grateful to have even the smudged and fuzzy ones here to give us some idea of what's gone. But they can't bring back the experience of the building. That's only possible in 3D, in real life.

Buildings are so fragile. A house that has kept out wind and weather for a thousand years can disappear in a night. The truth is that a celadon bowl has a better chance of surviving than a Regency villa. Copies of this book, unread and dust-covered, are more likely to be around in a few hundred years time than Greenway's Barracks. China, books, paintings, music, rugs survive because they aren't tied to a piece of dirt – dirt that might suddenly be wanted. Paradoxically, what brings buildings undone in the end is what seems to give them their strength: those deep foundations in the soil. Greedy heirs, ambitious developers and a few accommodating politicians and they're gone for ever.

Something of this paradox has entered the language in New South Wales where the law defines 'permanent' – as in 'Permanent Conservation Order' – to mean until the minister for planning decides otherwise. And 'conservation' doesn't mean preservation. At Walsh Bay a 'permanent conservation order' remains in force over those wonderful wharves and sheds even though they've been sold to a developer who will pull down one wharf, jazz up another and sweep away a stretch of shore sheds to build apartments. That's how we use the English language – and public assets – in the premier state.

Selling off Sydney is probably the oldest continuous tradition of government in New South Wales from 1788 until tomorrow. They treat this town like Norman Lindsay's Magic Pudding: however much is consumed, they reckon there's always a full bowl left of 'beef and beer, onions, bunions, corns and crabs, whiskers, wheels and hansom cabs'. That's the bedtime story of government in this town and Sydney is so prodigiously rich it's almost true – or so you might think until you see the evidence gathered here of what this city has lost.

But let me confess I looked at many of these photographs with only faint naggings of regret. Here are the streets and houses of a city which could never have survived intact, had to change, would rise and fall and rise again as every prosperous city has done since cities were invented. Elegant Wynyard Square was always a gonner. Phillip Street and those blocks of simple terraces running down to the Quay had to go. That a handful of houses in that quarter survive is a happy little miracle. And true enough, if Macquarie Street were still as it was in the heyday of these superb photographs, then we would have an urban wonder on our hands, something to out-New Orleans grotty New Orleans. But Macquarie Street was doomed all along by the wealth that built those extravagant tiers of verandahs in the first place.

Poverty preserves. Sydney is indebted to the misery of those poor generations who didn't have the cash to ruin Paddington and Surry Hills. Dictatorships don't do a bad job of preservation either. Alas, the evidence has been accumulating since the time of the pharaohs that appalling politics can make very fine cities – Venice, St Petersburg, Hobart. But would we want to live there? Not me. I like to live in this town for its energy, its prosperity and irreverence – qualities that also make it so keen to keep tearing itself down. In a great city that drive is always there and always has to be disciplined, but

it's a sign of life: the one impulse devouring and creating.

What's torn down never entirely disappears. Cities are memory too. Not much is left of Lawrence Durrell's Alexandria and scarcely anything survives above ground of the city of Antony and Cleopatra. Alexandria has been so prosperous for so long it's consumed itself half a dozen times over the centuries. Even the shoreline shifts and changes. The only indelible mark of the past is the pattern of the streets which the citizens, ignoring the efforts of the new Egypt, call by names as old as Rome.

Memory offers some consolation for those those who live in cannibalising towns like ours. Martin Place isn't just the banal plaza of today: in the imagination of the city, traffic is still running up the street and photographers are waiting in ambush outside the GPO. One of the greatest buildings of the century shares its site in our imagination with a phantom tram shed on the edge of the harbour. And even those far too young to remember know that in the early mornings Circular Quay can still be wreathed in smoke from Cazneaux's tugs.

Slim pickings, of course, but these bits and pieces of demolished Sydney are lodged in our memory to make sense of the city of today. What Sydney was is a key to how it works and why we love it still – despite everything. But to translate the pleasures of imagination and recollection into a crusade to preserve everything we can from this time forward is a mistake, a wonderfully romantic but lifeless mistake.

We hesitate to admit this because it seems at first an invitation to let the bulldozers rip. Yet it's not until we face the reality of how even civilised cities must, to some extent, be allowed to devour themselves that we can face the tough conclusion that governments, and only governments, can save what needs to be saved – by laws, by just administration of those laws and by the government's care for its own patrimony.

These rules seem to me unarguable: governments must build with pride and preserve with care.

Public buildings are not assets available to be sold as substitutes for effective taxation. Governments must not abuse open space. Parks are not the places to build football clubs, freeways, blocks of apartments or music schools. Buildings in parks – the less the better – can only be justified if they serve those parks. All of these rules have been broken over the last decades by New South Wales governments crying poor as Sydney grows richer and richer.

What rules can there be for the preservation of private buildings? The challenge, as always, is to know which buildings really matter. Rage is a clue. Look at all that's left of Subiaco – souvenired columns, plans, photographs – and your anger tells you this building mattered. Crucial to that sense of loss is knowing that a fine house came down to make way for a bitumen car park. Sometimes what we gain justifies what we lose: good streets on Millers Point for the Bridge, a fort and that old tram shed for the Opera House. But Subiaco, the Union Club, Burdekin House ...

It's easier to be angry about old buildings. But in this town young buildings are especially vulnerable, torn down just as citizens realise what connoisseurs have been saying all along. Those who love old buildings need to love them while they're young. We've still to come to grips with the loss to the spirit of this city caused by those wrecked Syd Ancher houses, demolished early Seidlers, that superb Ken Woolley office tower on Macquarie Street torn down to put a few extra shekels in the state's coffers.

In the end there is only one measure of what is worth preserving. Being unique is not decisive. To be beautiful may not be enough. The impact on the imagination is everything. What counts is a building's power to put us in contact with the past – which these days means the 1950s as much as the 1850s. The object of the exercise, deep down, is not preserving decor but offering ourselves a chance to absorb the spirit of other people and other times expressed in these most fragile materials: bricks and mortar.

House at Mosman for Billie and Hal Myers,
designed by Ken Woolley, architect.
Completed 1967, sold in 1984, demolished
in 1988. Photograph Harry Sowden.
Ancher Mortlock and Woolley

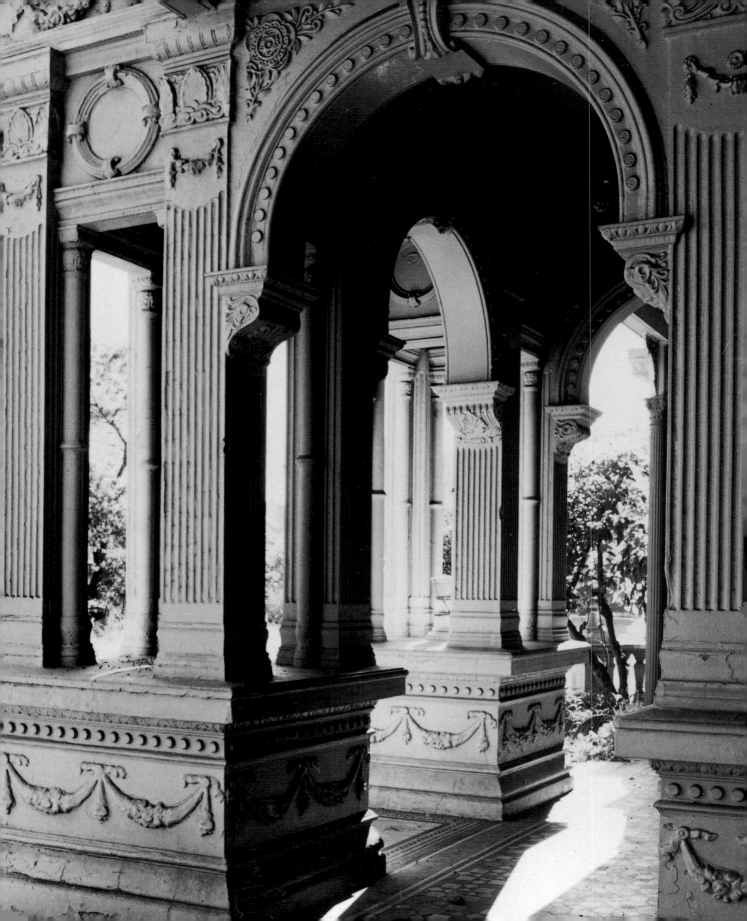

LEGAL ASPECTS: THE DEMOLITION OF BUILDINGS OF HERITAGE SIGNIFICANCE

Control of demolition of buildings of heritage significance traditionally has been under three sets of legislation: local government, planning and heritage legislation. Local government legislation traditionally has been concerned with matters of public health and safety.[1] Planning legislation is concerned with general town planning issues but also matters of cultural and heritage significance.[2] However, such matters are not assigned paramount status and are merely some of many planning and environmental considerations required to be taken into account, and balanced against each other, in determining development applications.[3] Heritage legislation, of course, also concerns matters of heritage significance, but the trigger for their consideration is usually the making of an interim conservation order or permanent conservation order in relation to a building of heritage significance.[4]

The upshot has been that before a building could be demolished, three different sets of legislation and associated regulations needed to be considered. Three different applications for approval may have been required, each requiring consideration of different matters. The reaction of the developers was to lobby for change. Like Thoreau who lamented 'Our life is frittered away by detail ... simplify, simply',[5] the developers called for a simpler, streamlined system. The politicians and bureaucrats were sympathetic. From 1 July 1998, the system was changed radically with the avowed intention of simplifying the regulatory procedures for obtaining approval for carrying out development, including demolition of buildings of heritage significance.

This paper is an attempt to summarise some of the more important features of the new system. Although only brief, this review should be sufficient to show that the new system, far from being simpler, is in many respects more complex and confusing than the old system. The result is another illustration of Karr's aphorism, 'The more things change, the more they are the same'.[6]

MAKING DEMOLITION OF BUILDINGS 'DEVELOPMENT'

A pivotal concept of Part 4 of the *Environmental Planning and Assessment Act* 1979 is that of 'development'. Not all actions (to choose a neutral word) constitute 'development' under the Act.

Prior to 1 July 1998, 'development' was defined to include primarily constructive actions such as the erection of a building on land, the carrying out of a work in, on, over or under land, the use of land or a building or work on land and the subdivision of land.[7] Defining development in constructive terms posed a problem for the control of demolition of buildings, which of course is a destructive action.

The demolition of the whole of a building could not come within any of the limbs of the definition of 'development'.[8] Demolition does not result in a 'work'; that concept refers to the physical product or physical result of labouring but not to the process itself.[9] Demolition does not involve the erection of a building. Notwithstanding that 'erection' is defined to include 'the rebuilding of, the making of structural alterations to, or the enlargement or extension of, a building', such terms presuppose that the building will remain in existence after such action has been carried out. It would be repugnant to the meaning of the expression 'the erection of a building' if 'the making of structural alterations to ... a building'

extended to include the concept of 'demolition' of the whole building.[10]

However, a partial demolition of a building, resulting in, for example, the making of structural alterations to the building so as to make it more suitable for its intended use, would amount to 'development'.[11] Whilst the demolition or replacement of a part of a building cannot constitute an alteration of that part,[12] the demolition or replacement of part of a building can constitute an alteration of the building viewed as a whole.[13]

Prior to 1 July 1998, the limited concept of 'development' could be extended by specific provision in an environmental planning instrument, such as a local environmental plan. In particular, s.26(d) of the Environmental Planning and Assessment Act 1979 then stated that an environmental planning instrument may make provision for or with the respect to '(d) controlling the demolition of buildings or works'.

Pursuant to this statutory provision, many local councils included in their local environmental plans provisions controlling demolition of buildings. Usually, the mechanism employed was to list items of environmental heritage in the local government area and to provide that development consent was required to demolish or alter such items. Thus, for example, Sydney City Council,[14] Woollahra,[15] Pittwater,[16] Manly,[17] Mosman[18] and Hunters Hill[19] local councils (amongst many others) made provision in local environmental plans to control the demolition of listed items of heritage significance.

The problem with this approach is two-fold. First, it relies upon the council taking positive steps to include a provision in its local environmental plan controlling demolition. Second, buildings not listed as items of environmental heritage would not be controlled;[20] at best, demolition of an unlisted building to make way for a new development such as another building might be a matter to be consid-ered in determining a development application for the new development.[21]

Amendments which came into effect on 1 July 1998 have extended the primary definition of 'development' in s.4(1) of the *Environmental Planning and Assessment Act* 1979 to include '(e) the demolition of a building or work'. 'Building' continues to include 'part of a building and any structure or part of a structure'.[22] Demolition of a building or work includes a reference to 'enclosing a public place in connection with the demolition of a building or work'.[23]

Having included demolition of a building in the primary definition of 'development', the reference in s.26(d) to demolition as one of the matters which could be controlled in an environmental planning instrument, such as a local environmental plan, became unnecessary and was removed.

The result is that all demolition, both of the whole and of any part of a building or work, is 'development' for the purposes of the *Environmental Planning and Assessment Act* 1979.

DEMOLITION OF A BUILDING REQUIRES DEVELOPMENT CONSENT

The planning system in New South Wales tradition-ally has regulated development in one of three ways: making it permissible without consent, permissible with consent or prohibited. To identify into which category a particular development falls it has been necessary to consult the relevant environmental planning instrument, usually the local environmental plan. The usual place to look is in the zoning table of such a plan.

The amendments have changed this planning system in certain respects. One change is to introduce the concept of 'prescribed activity'. If development is classified as a 'prescribed activity', it will require development consent to be obtained before being carried out, regardless of what an environmental planning instrument provides in

Villa Floridiana, Hunters Hill, built in 1847 for Jules Joubert, owned in the second half of the nineteenth century by the d'Apice family, and the home of Elaine and Douglass Baglin from 1957 until its sale in 1988. Demolished in 1989 following a successful appeal by developers against Hunters Hill Council's objection to its demolition. Photographed by Douglass Baglin in 1957

Previous spread: Preston, Birrell Street, Waverley, built in the 1880s, demolished by Waverley Bowling Club in 1966. Photograph by Jill Crossley; National Trust of Australia (NSW)

relation to that type of development.[24] Hence even if the zoning table of a local environmental plan provides that development of a specified type is permissible without consent, if that development is a prescribed activity, consent will be required.

A 'prescribed activity' means an activity specified in certain items in the Table to s.68 of the unamended *Local Government Act* 1993. These items include items 2 and 5 of the unamended Part A, namely 'demolish a building' and 'enclose a public place in connection with the erection or demolition of a building'.

Unlike the former system which required a change to the relevant environmental planning instrument to include a provision controlling demolition of buildings, for the time being the new system requires a change to the environmental planning instrument to remove the requirement to obtain consent for demolition of a building.[26] However, cl. 29 has a limited life. It will cease after 1 July 2000.[27] This means that by that date local councils will need to amend their local environmental plans to ensure that they include a requirement to obtain development consent for development which is currently a prescribed activity under cl. 29(1), such as demolition of buildings. In other words, a return to the old system.

The consequence is that for the time being consent is required for demolition of all buildings regardless of whether the building to be demolished is listed as an item of environmental heritage in the relevant environmental planning instrument.

CLASSIFICATION OF DEVELOPMENT NEEDING CONSENT

The new planning system divides development that needs consent in two different ways. First, development that needs consent can be either local development or State significant development. To be classified as the latter, development must meet one of the criteria in s.76A(7) of the *Environmental*

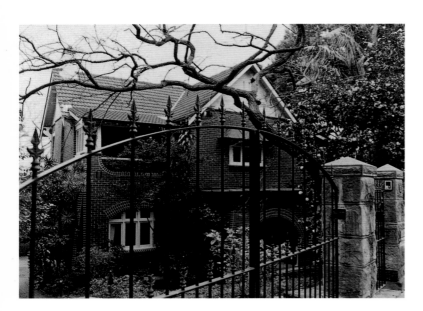

Leamington, 48 Darling Point Road, Darling Point built in 1908 as an investment property for Alfred Saunders, jeweller. Not listed as a heritage item in its 1995 Local Environment Plan, Woollahra Council subsequently opposed its demolition having recognised its heritage significance as part of an important streetscape, and as a house possibly designed by Florence Taylor, architect. Saved from demolition following a ruling of the Land and Environment Court in 1998. Photograph Woollahra Council

Planning and Assessment Act 1979, such as being declared in a State environmental planning policy or regional environmental plan or in the gazette as being State significant development.[28] If it is not State significant development, it is local development.[29]

Second, local development can be either complying or non complying development. Complying development is development that complies with predetermined development standards specified in an environmental planning instrument[30] and is not development of a kind specified in s.76A(6) of the *Environmental Planning and Assessment Act* 1979. That is to say, an environmental planning instrument cannot provide for development of a kind in s.76A(6) to be complying development. Of relevance is s.76A(6)(f) which provides that an environmental planning instrument cannot be made, for the purpose of making development complying development, so as to apply to land that comprises, or on which there is, an item of environmental heritage:

 (i) that is subject to an interim heritage order under the Heritage Act 1977 or that is listed on the State Heritage Register under that Act[31]; or

 (ii) that is identified as such an item in an environmental planning instrument.

Thus, demolition of buildings of heritage significance which are subject to a form of protection order under the *Heritage Act* or are listed as items of environmental heritage under an environmental planning instrument cannot become complying development, but demolition of buildings of heritage significance which are not so protected or listed can become complying development.

The difference between complying and non-complying development is primarily two-fold: first, the person who can grant the required consent to carry out the development differs and second, the nature of the decision that can be made, including the conditions upon which consent can be granted, differ.

If development is complying development, the person carrying out the complying development may be issued with a complying development certificate.[32] Such certificate is taken to be a development consent in the same terms as the certificate.[33] There is no discretion to refuse a complying development certificate if the development complies with the relevant development standards applicable to it.[34] The only conditions that may be imposed are those prescribed by the regulations[35] or as may be required expressly in the environmental planning instrument or development control plan.[36]

Alternatively, the person carrying out the complying development may decide to lodge a development application with the consent authority seeking development consent in the usual way.[37]

If the development is not complying development, a development application is lodged and is dealt with pursuant to Division 2 of the *Environmental Planning and Assessment Act* 1979, except if the development is also integrated development in which case Division 5 will also apply. The consent authority (usually the local council) is required to take into consideration the matters in s.79C which include the provisions of relevant environmental planning instruments and development control plans as well as the likely impacts of the development, including environmental impacts on the natural and built environments, and social and economic impacts in the locality.[38] These matters would permit most aspects arising as a result of the demolition of heritage buildings to be considered by the consent authority.

The consent authority has a discretion to refuse consent or to grant consent, including to grant consent on conditions.[39] There are various rights of review and appeal.[40]

DEMOLITION OF BUILDINGS AND WORKS CAN ALSO BE INTEGRATED DEVELOPMENT

Non complying development can also be 'integrated development'. Integrated development is development that requires development consent under the *Environmental Planning and Assessment Act* 1979 as well as one or more approvals under the statutes specified in s.91 of that Act, one of which is an approval under s.58 of the *Heritage Act,* 1977 to do an act specified in s.57(1) of that Act including demolition or alteration of the building which is subject to an interim conservation order or permanent conservation order.

In these circumstances, before the consent authority can determine a development application for the proposed demolition of a building,[41] the consent authority must obtain from the Heritage Council the general terms of any approval that the Heritage Council would be minded to grant under ss.62 and 63 of the *Heritage Act* 1977 in relation to an application under s.59 of that Act.[42] The consent authority is obliged, if it determines to grant consent to the development application, to grant a consent that is consistent with the general terms of the approval notified by the Heritage Council, including imposing conditions which the Heritage Council could impose under the *Heritage Act*.[43]

If the Heritage Council informs the consent authority that it will not grant an approval under the *Heritage Act* 1977, the consent authority is obliged to refuse consent to the development application for integrated development.[44]

If the Heritage Council fails to inform the consent authority of its intention as to whether it will refuse or approve the application for approval under the *Heritage Act* and, if the latter, the general terms of approval, within the time specified in the regulations,[45] the consent authority may determine the development application without further regard to matters relating to any application under the

FLOWCHART OF APPROVAL PROCESS FOR DEMOLITION OF BUILDINGS

Demolition is 'development'

▼

Does the relevant EPI require consent for the proposed demolition?

▼

No

▼

Is the proposed demolition to be carried out before 1 July 2000?

No / **Yes**

Has the relevant EPI been altered to remove demolition from category of 'prescribed activity?'

Yes / **No**

Proposed demolition may be carried out without development consent.

Proposed demolition is 'prescribed activity' and needs consent.

Yes

▼

Is the proposed demolition State significant development?

Yes

▼

DA to be lodged with Minister as consent authority.

No

▼

Proposed demolition is local development.

▼

Is the proposed demolition of an item of environmental heritage to which s.76(b)(f) applies?

▼

Yes

▼

Development is not complying development and DA to be lodged with local council as consent authority.

No

▼

Has the relevant EPI specified that the proposed demolition can be addressed by predetermined development standards?

▼

No / **Yes**

Proposed demolition is complying development and complying development certificate can be obtained pursuant to Div.3.

Does an approval under the *Heritage Act* need to be obtained for proposed demolition?

Yes

▼

Proposed demolition is 'integrated development' and DA is determined pursuant to Div. 2 and Div. 5 (and Div. 4 if State significant development).

No

▼

Proposed development is not integrated development and DA is determined pursuant to Div. 2 (and Div. 4 if State significant development).

Heritage Act. Furthermore, the Heritage Council, when application is made to it for approval under the *Heritage Act*, is obliged to grant an approval under that Act in terms not inconsistent with the development consent granted by the consent authority.[46]

In any event, once development consent has been granted by a consent authority, the Heritage Council is obliged to grant an approval to any application that is made under the *Heritage Act* within three years of the date of the development consent for the integrated development in terms not inconsistent with the development consent.[47]

SUMMARY

The current regulatory system covering the demolition of buildings and works can be summarised by way of a flow chart. This is perhaps the easiest way to express the complicated regulatory system we now have. It remains to be seen whether this system will be any more effective in controlling the demolition of buildings of heritage significance. One suspects that without a strong commitment of the executive arm of government (including both the state government and local government) to heritage conservation, the new regime will be no more effective than its predecessor.

1 See *Smith v. Wyong Shire Council* (1970) 19 LGRA 61 at 63 and *Murrell v. Mosman Council*, unreported, Land and Environment Court, Talbot J., 28 August 1996 at p.6.

2 *Murrell v. Mosman Council*, supra, p.6.

3 See list of considerations in the former s.90(1) of the *Environmental Planning and Assessment Act* 1979.

4 See ss.26, 35A and 41 of the *Heritage Act* 1977.

5 H.D. Thoreau, *Walden* 'Where I Lived and What I Lived For'.

6 A Karr, *Les Guepes*, January, 1849 ('Plus ça change, plus c'est la même chose' in the original French).

7 S.4.

8 *Drummoyne Municipal Council v. Lebnan* (1974) 131 CLR 350 at 360; *Auburn Municipal Council v. F N Eckold Pty Ltd*. [1974] 2 NSWLR 148 at 153 affirmed (1975) 34 LGRA 114; *National Trust of Australia (VIC) v. Australian Temperance & General Mutual Life Assurance Society Ltd* (1976) 37 LGRA 172 at 185; and *Customs & Excise Commissioners v. Viva Gas Appliances Ltd*. [1983] 1 WLR 1445, at 1451.

9 *Parramatta City Council v. Brickworks* (1972) 128 CLR 1 at 24-5 and *Mulcahy v. Blue Mountains City Council* (1995) 87 LGERA 422 at 428.

10 A.J. Nott, *Environmental Planning and Development Law* (NSW), Penman Press, 1982, p.12 and see *Customs and Excise Commissioners v. Viva Gas Appliances Ltd* [1983] 1 WLR 1445 at 1451.

11 *Coleshill District Investment Co Ltd v. Minister of Housing and Local Government* [1969] 2 All ER 525 at 529-30, 535, 537-8, 542-3.

12 The replacement of that part would be a substitute for the old and not an alteration of it.

13 See *Shimizu (UK) Ltd v. Westminster City Council* [1997] 1 All ER 481 at 496-7.

14 Central Sydney Local Environmental Plan 1992 - Conservation of Heritage Items: See *Peddle Thorp & Walker Pty Ltd v. Sydney City Council*, unreported, Land & Environment Court, Bignold J, 4 December 1997 ('Transport House', Sydney)

15 Woollahra Local Environmental Plan 1995: see *Andriotakis v. Woollahra Municipal Council* (1998) 97 LGERA 310 ('Leamington', Darling Point).

16 Pittwater Local Environmental Plan 1993: see *Bajune Pty Ltd v. Pittwater Council*, unreported, Land and Environment Court, Assessors Bly and Brown ('Rock Lily', Mona Vale)

17 Manly Local Environment Plan 1988: see *Lend Lease Development Pty Ltd v. Manly Council* (1997) 92 LGERA 420 and *Lend Lease Development Pty Ltd v. Manly Council* (No. 2), unreported, Land and Environment Court, Lloyd J, 30 June 1998 (St Patrick's Estate Manly).

18 Mosman Local Environmental Plan: See *Flower and Samios Pty Ltd v. Mosman Municipal Council*, unreported, Land and Environment Court, Stein J, 24 June 1993 (Sacred Heart Church Complex, Mosman) and *Murrell v. Mosman Municipal Council*, supra, Talbot J. (dwelling at 5 Bond St. Mosman)

19 Hunters Hill Local Environmental Plan No. 1: see *Villa Floridiana Pty Ltd v. Hunters Hill Municipal Council* (1989) 39 APA 24 and on appeal (1990) 70 LGERA 62 ('Villa Floridiana', Hunters Hill).

20 See *Murrell v. Mosman Council*, supra and *Andriotakis v Woollahra Municipal Council* (1998) 97 LGERA 310.

21 See *Flower and Samios Pty Ltd v. Mosman Municipal Council*, supra.

22 S.4(1) of the *Environmental Planning & Assessment Act* 1979.

23 S.4(2)(e), ibid.

24 See Cl. 29(1), (3) and (7) of *Environmental Planning & Assessment (Savings and Transitional) Regulation* 1998. See also Cl. 29A which ensures that demolition will not be prohibited under the relevant environmental planning instrument.

25 See Cl. 3 of *Environmental Planning & Assessment (Savings and Transitional) Regulation* 1998.

26 See Cl. 29(7), ibid.

27 See Cl. 29(11), ibid.

28 See, for example, State Environmental Planning Policy No. 56 - Sydney Harbour Foreshores and Tributaries, Part 3 and Schedule 1 which declares certain strategic foreshore sites, including some with heritage significance, to be State significant development.

29 S.76A (4) of the *Environmental Planning & Assessment Act* 1979.

30 S.76A (5), ibid.

31 S.76A(6)(f)(i) was amended by the *Heritage Amendment Act* 1998, S.4, Sch 2, Cl. 2.2.

32 S.84A(1) of the *Environmental Planning & Assessment Act* 1979.

33 S 84A (4), ibid.

34 S 85A (7), ibid.

35 S.85A(6)(a) and Cl. 78 and Part 7 of the Environmental Planning and Assessment Regulation 1994 (as amended).

36 S.85A(6)(a) the *Environmental Planning & Assessment Act* 1979.

37 S.84A(5), ibid.

38 S.79C(1)(a) and (b), ibid.

39 S.80(1) and s.80A, ibid.

40 S.82A and s.97, ibid.

41 Demolition being both non complying, local development as well as integrated development.

42 S.91A(2) of the *Environmental Planning & Assessment Act* 1979.

43 S.91A(3), ibid.

44 S.91A(4), ibid.

45 Usually 40 days: see Cl. 53B of the *Environmental Planning & Assessment Regulation* 1994 (as amended).

46 S.91A(5) of the *Environmental Planning & Assessment Act* 1979.

47 S.93(1),(2) and (4), ibid.

EMOH RUO:
CAPTURING THE IMAGE

A number of houses of cultural or social significance initially proposed for this book will not be found between its covers. Photographs of these worthy candidates could not be found. Surprisingly, not all were nineteenth century houses. Some were built as late as the mid-twentieth century – surviving for only twenty or thirty years – and now gone, without a visual record of their existence.

Family albums, in some instances, yielded treasured snapshots of these houses, evoking happy memories of their occupation – celebrations around the Christmas tree, a family birthday party, a backyard barbecue – but with the house as a backdrop, just a glimpse of its architectural detail, a hint of its setting.

No longer, as they did in the late nineteenth and early twentieth century, do professional photographers canvass the suburbs, travelling from house to house, offering proud owners a formal photograph of their prized possession – complete with thick cardboard mount decorated with scrolls and flourishes – such as those that abound in the Small Pictures File in the Mitchell Library, State Library of New South Wales.

More affluent owners would commission an album of photographs: the house resplendent in its landscaped grounds, its vistas (to and from), its entrance hall, drawing and dining rooms dressed in the latest of fashion. It is such albums of Pakenham at Hornsby and Oyama in Manly, or the series by Harold Cazneaux of Brooksby, Double Bay, twenty years later, that heighten our awareness of what has gone. Not just the architecture, the bricks and mortar. Gone too are the vistas, gardens and interiors and the associated lifestyle.

The commissioned photographs of David Scott Mitchell's house at Darlinghurst inform us more of its owner than its architecture. Do the rooms contain valuable furniture and fittings? Are they exceptional wallpapers? Such things are not noticed here. One cannot look beyond the priceless paintings that cram the walls, the myriad rare books stacked perilously on every horizontal surface. Here in its context is this remarkable collection of Australiana that, through Mitchell's passion and generosity, we are all now privy to. One generation had the foresight to commission these photographs; a later one let the house disappear.

The late nineteenth century canvass of Parramatta by peripatetic photographers, Henry Beaufoy Merlin and Charles Bayliss, combine with the work of local photographers, Charles Tuke and Henry William Burgin, to provide a comprehensive picture of the town at that time. While their prints of its houses, shops, churches, inns, small and large industries and public buildings, survive individually in private ownership or in institutions, a substantial collection of them, in the form of glass lantern slides, was amassed by local resident Dr Andrew Houison, first president of the Australian Historical Society.

His nephew, James K. S. Houison, later owned and added substantially to the collection of which the Parramatta slides formed a small part. On his death in 1968, this extraordinary collection of more than 8000 lantern slides, a few the images of buildings designed or constructed by his grandfather, James Houison, passed to the Society of Australian Genealogists. One hundred of the lantern slides were reproduced in *Parramatta: a Town Caught in Time, 1870* (1995), capturing between its

covers a Parramatta that has since disappeared under waves of twentieth century demolitions.

One such travelling amateur photographer at the turn of the twentieth century was Josephine Ethel Foster who, with her husband, and a keen sense of history, traversed Sydney, photographing its early colonial houses and buildings, and, in 1905, returning to Annandale to capture its demolition. Perhaps better known, particularly by family historians, for their recording of the Devonshire Street Cemetery, where Josephine and Arthur Foster, photographed the monuments and transcribed their epitaphs, before the site was cleared for Central railway.

The Fosters' collection of lantern slides, photographic prints and scrapbooks was bequeathed to the Royal Australian Historical Society of which Josephine Ethel was a foundation member in 1901. Their work together with that of other amateur photographers – members Charles Bertie, Captain Jack Watson, C. Price Conigrave and John Powell, form the basis of the society's rich pictorial sources.

The first two decades of the twentieth century saw the inner city photographed – for entirely different motives – by the city council and government agencies. Large albums held in the Mitchell Library, of views of 'cleansing operations' (PX*D90-95) record hundreds of cottages, shacks, shanties, back lanes and courts that were quarantined and many subsequently razed, when fear of the 'plague' paralysed Sydney in 1900.

Other photograph albums in the Mitchell Library and in the Sydney City Council's archives, record streets, often house by house – for compensation purposes – before their resumption and demolition for road widening. But the clarity of detail of these buildings is often overpowered by the despair, the sense of helplessness, captured on the faces of their occupants, usually standing at the entrance or looking from balconies. Every image of every house contained in these voluminous albums represents the dispossession of its inhabitants, all hapless victims of the city's 'improvements'.

A few miles to the east, in more salubrious surroundings, solicitor Arthur Wigram Allen had a darkroom at Merioola, his home at Edgecliff, and staff to help process and maintain his photographs. The volume of his work suggests that Allen was a fanatical photographer, the camera always a presence at home, at his friends' homes and on the family's frequent social excursions. The prints, extensively captioned and mounted in albums, are now in the Mitchell Library. They span about forty years dating from the last decade of the nineteenth century, and capture Sydney society - albeit strictly 'establishment'.

Other talented amateur photographers – professionals in other fields – have been the members of the Historic Buildings Committee of the National Trust of Australia (NSW) whose voluntary work of identifying and photographing buildings of heritage significance throughout the state, has

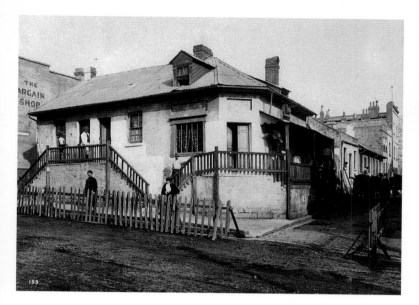

contributed substantially to the trust's photographic archive – a source that has provided many images for this publication. Since its formation in 1945 the trust has battled for the preservation of the built and natural environment. Despite major campaigns waged in 1961, Subiaco at Rydalmere and St Malo at Hunters Hill were not saved, but their destruction was the catalyst that increased membership and public support for the work of the trust.

In the late 1940s the National Trust had assisted the Cumberland County Council (the then planning authority for the Sydney region) to compile its first register of historic buildings. These buildings were featured in publications prepared for the council in the 1960s by town planner and historian, Helen Baker (now Proudfoot). Her later reports and publications provide a comprehensive pictorial coverage of buildings of heritage significance in Sydney's western and south-western suburbs. The expansion of suburbia and the burgeoning need for subsidised housing in the early 1970s saw the Macarthur Development Board formed to encourage industry and commerce to the Campbelltown area and to oversee the development of its proposed urban precincts. Prior to these subdivisions, Proudfoot, was commissioned by the board, to identify and photograph the district's nineteenth century structures. Her four-volume report, encompassing an area stretching from Liverpool to Camden, includes photographs of many houses that have since disappeared from the area's once rural landscape. How many of the buildings photographed by her for *Exploring Sydney's West*, have gone since its publication in 1987?

Artist Daphne Kingston has amassed a comprehensive photographic record of Sydney's slab buildings. More than thirty-five of the one hundred buildings featured in her *Early Slab Buildings of the Sydney Region*, have been demolished since its publication in 1985.

Economic rationalism in the past two decades has seen the demise of a number of photographic branches of state government departments and their collections stored in locations where retrieval can be difficult. The early photograph collection of the Heritage Council (now Heritage Office of New South Wales) is one such example. The extensive collections of the Government Printer have been divided and transferred, some to the State Records Authority where they can be viewed on contact prints and microfilm. Those transferred to the State Library of New South Wales are accessible on videodisc, just one of the library's videodiscs that contain a treasure trove of images, including the earliest photograph reproduced in this publication - that of Drummoyne House captured in the 1850s by Professor John Smith.

Following the passing of the *Heritage Act* in 1977 and the *Environmental Planning and Assessment Act* in 1979, the majority of metropolitan local government authorities commissioned surveys of their areas to record and photograph structures and

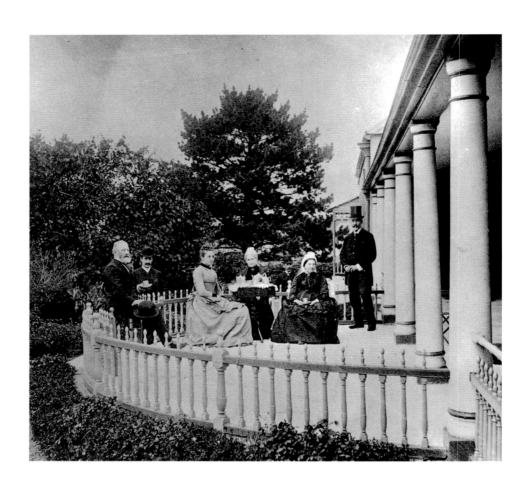

Members of the Johnston family on the terrace at Annandale. The house was demolished in 1905. Photograph by Josephine Ethel Foster. Mitchell Library, SLNSW

Following spread: 177 Edinburgh Road, Castlecrag, built in 1936 by the sculptor Bim Hilder for his wife Roma Hopkinson, and himself. Roma, a successful artist, photographed in the living room in the late 1930s. Demolished in 1994. Photograph courtesy of Kimble Hilder

natural features of heritage significance. Nineteenth and early twentieth century buildings of architectural significance predominate most of the reports. It would seem that only those surveys to which historians made a major contribution, acknowledged architecturally unremarkable houses and other structures, of social significance to the local community. The omission of these structures, led indirectly to the demolition of many.

Copies, with original photographic prints, of most of the heritage surveys were also deposited in the Department of Planning library. The negatives, passed to the relevant local government authority, as a condition of the contract. Many of these collections of negatives can no longer be found. Some may survive, hidden in the back of a cupboard. In many instances all that is available in local government libraries are second or third generation photocopies of the prints.

Throughout the 1980s the emphasis on history changed. No longer just great men and great houses, the focus shifted to social history. This shift has been acknowledged with the introduction of the State Heritage Inventory with assessment criteria that take into account a building's historical, aesthetic, technical and social significance. The inventory includes items protected by heritage schedules in local and regional environmental plans. Most local government authorities now employ heritage advisers and town planners and many are currently revising their heritage surveys.

The proliferation of local histories published for the bicentenary in 1988 drew attention to local studies collections in local government libraries and resulted in donations of photographs. Photographs by Ian G. Scott in 1958 of more than five hundred houses in Woollahra, were donated to the Woollahra Library, Local Studies Collection. The photographic collections of local historical societies also burgeoned in the 1980s. The number of photographs from these collections reproduced in this publication reflects their growing importance as a source.

Local government libraries such as Ryde, Canterbury and Woollahra as well as local history organisations have published material focusing on the built environment. In 1969 the Hunters Hill Trust published its first edition of a photographic survey of its houses in *Old Buildings of Hunters Hill*. Architectural historian Peter Reynolds has published widely in books and journals on houses in the Leichhardt local government area. Willoughby Historical Society produced a series of well-researched illustrated volumes on the houses of the district. Helen Barker and May Elven of the Hornsby Shire Historical Society published the results of their extensive research of the district in *Houses of Hornsby Shire*, in 1989 with a second volume by Barker in 1998. Canterbury City Council Library's *Heritage Panels in the City of Canterbury*, researched by local historians Lesley Muir and Brian Madden, has been published and is also accessible on Internet. Also available through the Internet, is the vast collection of photographs acquired since 1992 by the Mitchell Library, State Library of New South Wales.

At the end of the twentieth century, members of Ashfield and District Historical Society are taking over the role of the nineteenth-century travelling photographer. For the year 2000 they propose to capture for posterity, an image of every residence in their municipality. An admirable and ambitious project, and one that other historical societies and local government libraries should consider.

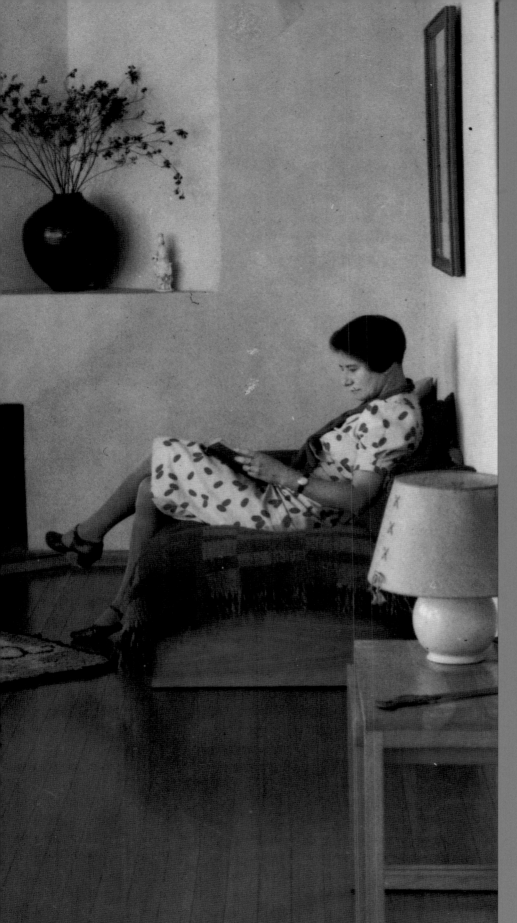

DEMOLISHED
HOUSES
OF SYDNEY

METROPOLITAN
SYDNEY

Hawkesbury R

Broken Bay

Palm Beach

Mona Vale

Richmond • •WINDSOR

HORNSBY •

Frenchs
Forest

Manly

Chatswood

Blacktown

Ryde

SYDNEY

PENRITH •

PARRAMATTA

Prospect

Randwick

Ashfield

Nepean R

Bankstown

Botany

Rockdale

Mulgoa

LIVERPOOL

*Botany
Bay*

Leppington

Sutherland

Cronulla

Ingleburn

*The Royal
National
Park*

Narellan

CAMPBELLTOWN

N

0 5 10 15km

THE CITY

Wharf House
Lower George Street, Sydney

Built on Sydney Cove in 1802 by the merchant Robert Campbell senior, adjacent to his warehouses and wharves, and probably the first house in the colony built with a verandah. This 1870 photograph also shows the two-storey pedimented block added in 1822 to the southern end of the house by Francis Greenway, architect. Demolished in the late 1880s and Sydney Morgue erected on part of the site.

Photograph: SPF (BM), Mitchell Library, SLNSW

Richard Hill's House
Bent Street, Sydney

Built in the 1820s for Richard Hill, pastoralist and politician, the house remained in the ownership and occupation of the Hill family until the early twentieth century. Demolished in 1929, the vacant site was used as a car park until the construction of Chifley Tower in the 1990s.

Photograph: SPF (BM), Mitchell Library, SLNSW

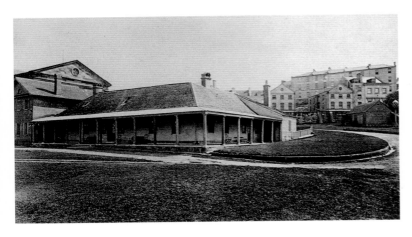

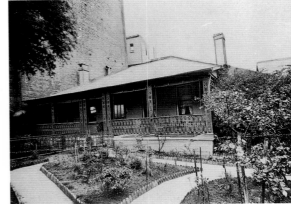

Isaac Nichols's House
Lower George Street, Sydney

Built in 1808 for Isaac Nichols, first postmaster of New South Wales, and used also during his ownership as the colony's post office. In 1822 when occupied by the entrepreneur John Macqueen, tenders were called by Francis Greenway, architect, for additional work, the extent of which is unknown. By the 1840s it was the Australian Hotel. Located near the southern corner of George and Alfred Streets, the house was demolished c.1889 for a Fire Brigade station. The keystone inscribed 'I.N May 30 1808' survives in the Mitchell Library, State Library of NSW.

Photograph: Royal Australian Historical Society

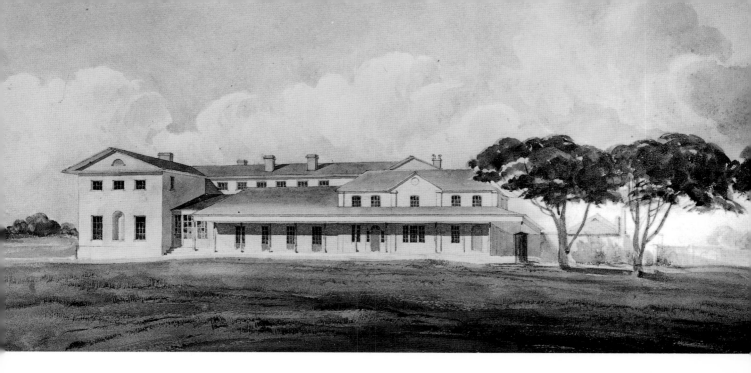

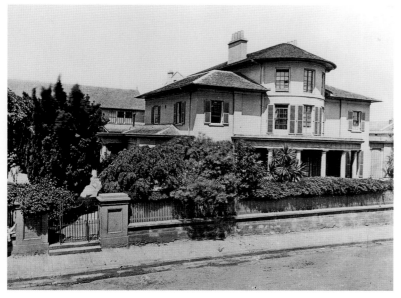

Above

Government House
Sydney

This 1836 watercolour by Charles Rodius depicts the first Government House in its final form: Governor Phillip's house built in 1788 (right foreground), additions for Governor King (centre), the two-storey pedimented block by Francis Greenway, architect, for Governor Macquarie (left) and to the rear additions and alterations by Henry and William Dumaresq for Governor Darling. Demolished in 1845-46 for the extensions of Bridge and Phillip Streets, some foundations survive under First Government House Place and possibly under Bridge Street.

Illustration: Charles Rodius, Government House, Sydney, 1836, watercolour, Mitchell Library, SLNSW

Above

Robert Campbell's House
Bligh Street, Sydney

Built in the late 1820s for Robert Campbell, junior, and attributed to Francis Greenway, architect, this 1870 photograph shows the house when occupied by the Union Club. It was demolished in 1884 for a new Union Club; now the site of the Wentworth Hotel.

Photograph: SPF (BM), Mitchell Library, SLNSW

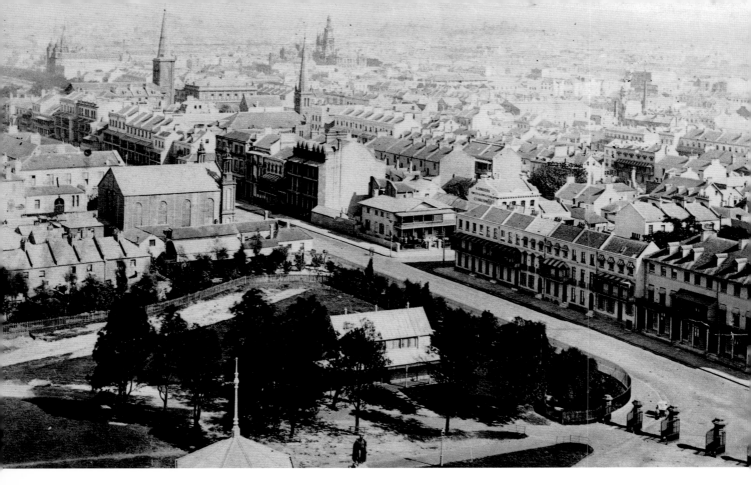

Above

Macquarie Street

Sydney

Photographed c.1880 from the Garden Palace looking south from Bent Street, its brick and sandstone townhouses were progressively demolished for commercial buildings. Beyond is late-nineteenth century Sydney still predominantly residential, its skyline broken only by the spires of (from left) St George's Presbyterian Church (Pitt Street), St James's Church of England (King Street), St Stephen's Presbyterian Church (Phillip Street) and the tower of Sydney Town Hall.

Photograph: SPF (BM), Mitchell Library, SLNSW

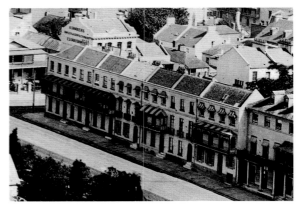

Above

Horbury Terrace

Macquarie Street, Sydney

Built in the 1840s, on the corner of Macquarie and Hunter Streets, for William Hutchinson and Archibald Wood. Partially demolished in 1909, two of the seven houses (5th and 6th from left) remain, now converted to offices.

Photograph: SPF (BM), Mitchell Library, SLNSW (detail)

Left and below

Burdekin House
Macquarie Street, Sydney

Built in 1841 probably by James Hume, architect, for Thomas Burdekin, shopkeeper, as the grandest town house in Sydney, it was owned and occupied by members of the Burdekin family until its sale in 1922. When a hotel was proposed on the site, the Royal Australian Historical Society lobbied government to acquire the house for cultural purposes. Purchased by the trustees of St Stephen's Presbyterian Church and demolished in 1933 for a new church to replace the existing one in Phillip Street due to be demolished for the extension of Martin Place. An early *cause celebre* of the conservation movement.

Photograph: (left) Royal Australian Historical Society: (below) SPF, Mitchell Library, SLNSW

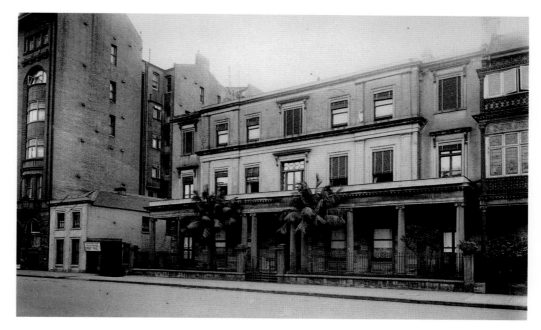

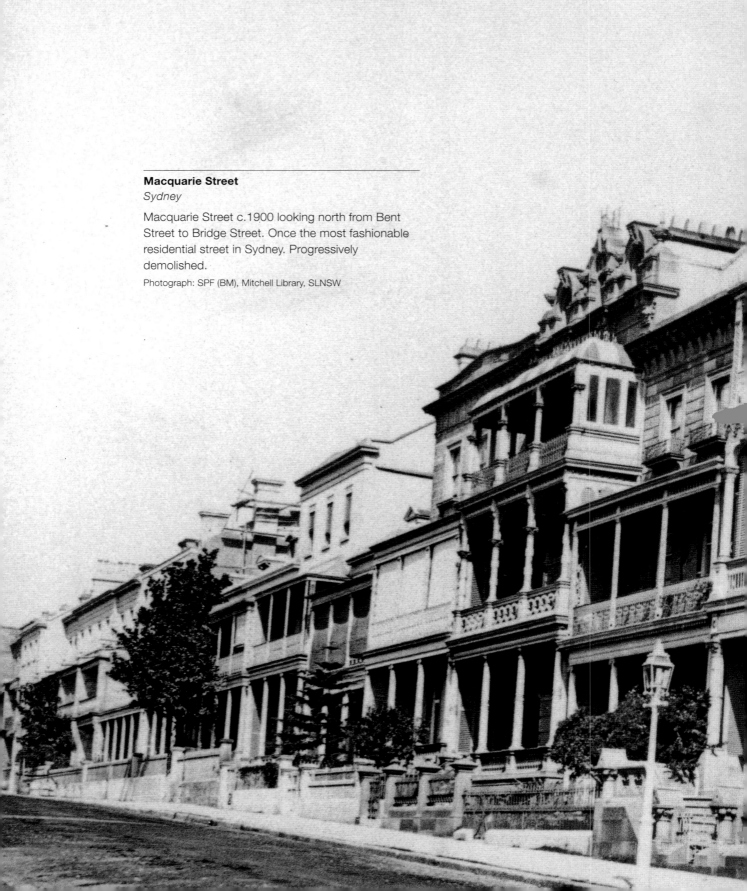

Macquarie Street

Sydney

Macquarie Street c.1900 looking north from Bent Street to Bridge Street. Once the most fashionable residential street in Sydney. Progressively demolished.

Photograph: SPF (BM), Mitchell Library, SLNSW

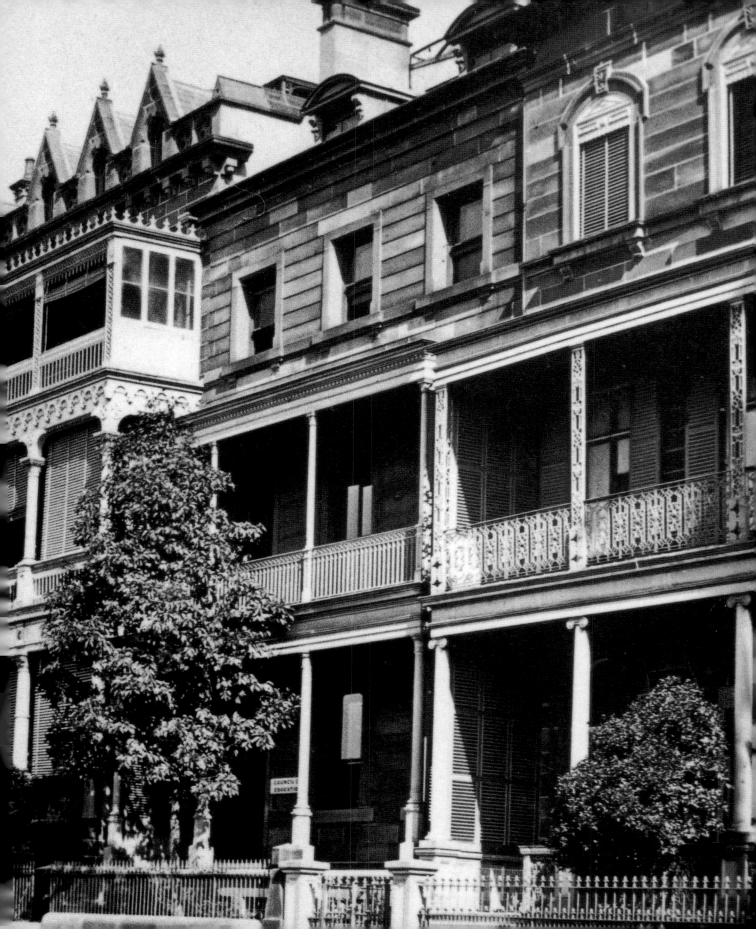

Phillip Street

Sydney

Phillip Street c.1871 from St James's Church of England spire, looking north to Circular Quay and beyond to North Sydney with part of Castlereagh Street visible on left. Progressively demolished for commercial buildings.

Photograph: SPF (BM), Mitchell Library, SLNSW

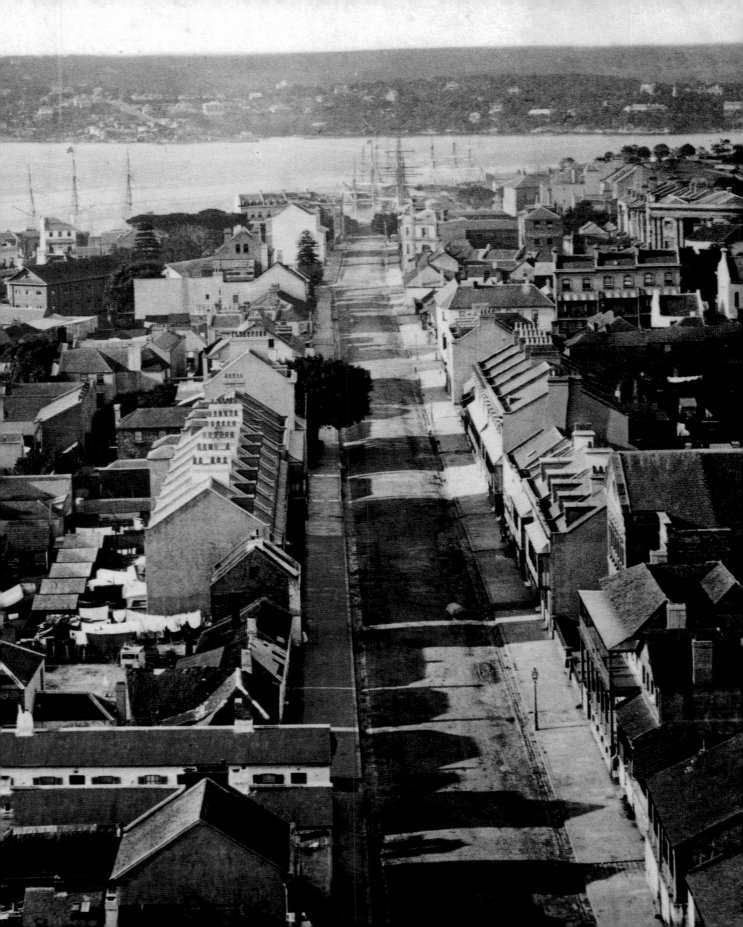

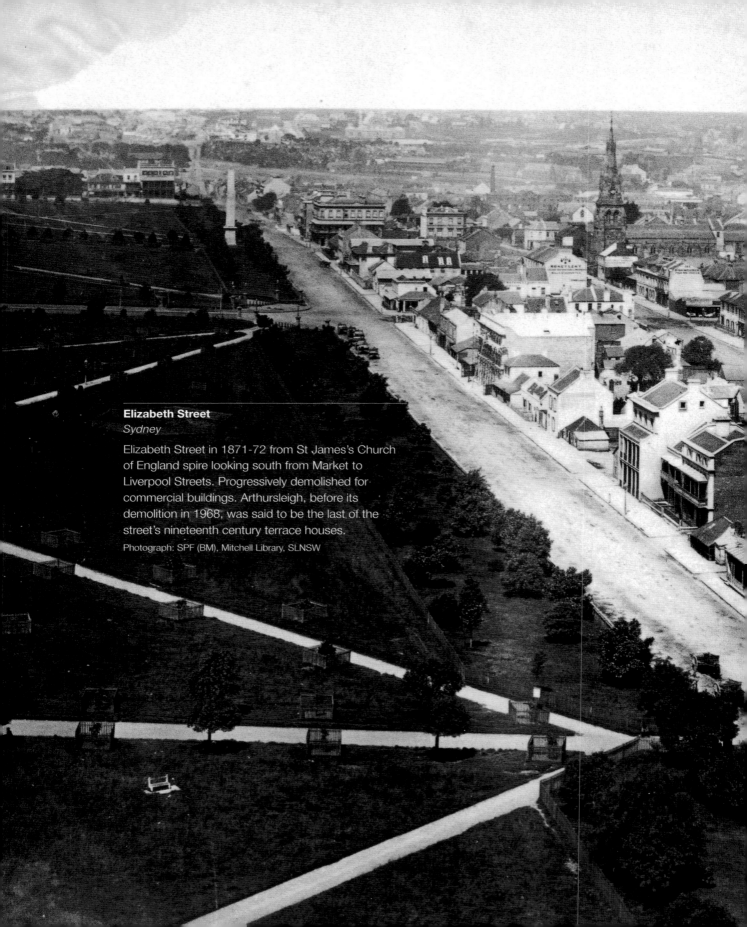

Elizabeth Street
Sydney

Elizabeth Street in 1871-72 from St James's Church of England spire looking south from Market to Liverpool Streets. Progressively demolished for commercial buildings. Arthursleigh, before its demolition in 1968, was said to be the last of the street's nineteenth century terrace houses.

Photograph: SPF (BM), Mitchell Library, SLNSW

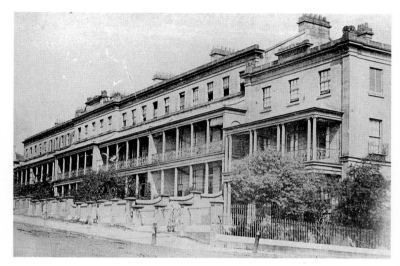

Lyons Terrace

Liverpool Street, Sydney

A terrace of five houses facing Hyde Park, built in 1841 by John Verge and John Bibb, architects, for Samuel Lyons, auctioneer. The house on the extreme left was demolished in 1910 for Wentworth Avenue; the next house and central house for the Australian Picture Palace. The two remaining houses and the adjoining house to the right were demolished for the YWCA headquarters and hostel in 1923.

Photograph: (above) SPF (BM), Mitchell Library, SLNSW; (below) Sydney City Council Archives

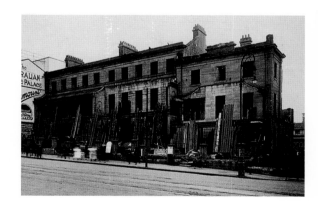

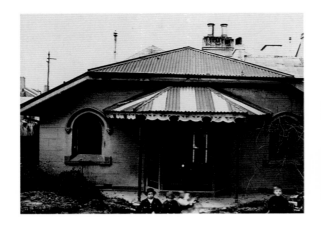

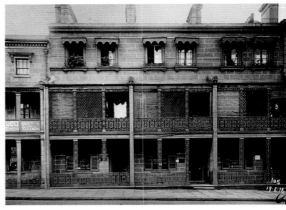

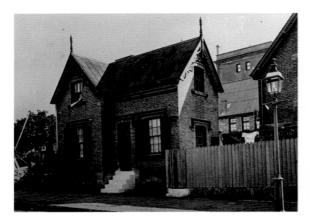

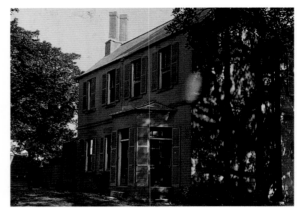

Top

Cottage

Bourke Street and Cross Lane, Woolloomooloo

Photograph: Sydney City Council Archives

Above

Cottage

Yurong Street, Sydney

These elegantly detailed dwellings were two of the many small mid-nineteenth century houses located in streets running off William Street, demolished c.1913 by the city council.

Demolitions for the Eastern Suburbs Railway cut a swathe through Woolloomooloo in 1968; Green Bans by the Builders Labourers' Federation in the1970s halted the proposed wholesale demolition of hundreds of terraces for high-rise subsidised housing and instead saw terrace-style accommodation built for the residents.

Photograph: Sydney City Council Archives

Top

Houses

171-177 William Street, Sydney

In 1916 the city council demolished houses, of which 171-177 were typical, along the southern side of William Street for road widening purposes. Prior to demolition the council recorded the houses, in a remarkable series of photographs. The despair of its displaced residents and the destruction of this significant Victorian streetscape is captured dramatically in Max Kelly's *Faces of the Street* (1982).

Photograph: Mitchell Library, SLNSW

Above

Christ Church St Laurence Parsonage

Pitt Street, Sydney

Built in 1845, and remodelled in the 1860s by Edmund Blacket, architect, the parsonage was demolished for the approach to Central station in 1906.

Photograph: Royal Australian Historical Society

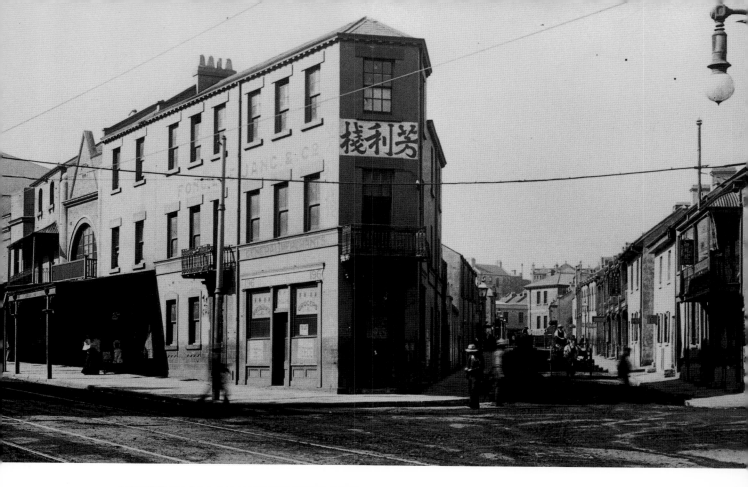

芳利棧

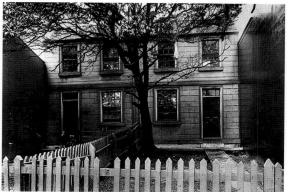

Above

Houses

Lower Campbell Street, Surry Hills

An unusual pair of mid-nineteenth century timber-framed houses with timber detailing in imitation of ashlar stonework. Demolished by the city council as part of its slum clearance, c.1910.

Photograph: Sydney City Council Archives

Above

Wexford Street

Sydney

The houses in this street were flattened in 1906 to make way for the construction of Wentworth Avenue to improve access to Central station. But Wexford Street formed the heartland of Chinatown and anti-Asian sentiment was high at that time. Shirley Fitzgerald in *Red Tape, Gold Scissors* (1997) recounts that 'an estimated 724 people had their houses demolished by this resumption, and in the official records of this process there is a certain satisfaction at having dealt with a "Chinese" problem so efficiently.'

Photograph: Sydney City Council Archives

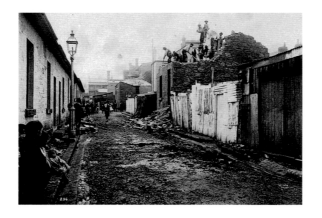

Left

Johnstone's Lane
The Rocks, Sydney

Fear of the spread of the 'plague' in the early 1900s led to the resumption of most of The Rocks and Millers Point. Residents were quarantined and their houses whitewashed or demolished. Only a small portion of the area had been affected, nevertheless the Sydney Harbour Trust's cleansing operations were a means to rid the area of substandard housing.

More streets disappeared in the 1920s to make way for Sydney Harbour Bridge. The proposed wholesale demolition of the area following its resumption by the Sydney Cove Redevelopment Authority in 1968, was halted by a successful campaign waged by local residents with the support of the Builders Labourers' Federation.

Photograph: Mitchell Library, SLNSW

Below

Wynyard Square
Sydney

Once the site of the colony's military barracks, this nineteenth century city square, photographed c.1879 from Margaret Street, was lined with the residential terraces of York, Wynyard, Carrington Streets, all of which were progressively demolished for commercial buildings.

Photograph: SPF (BM), Mitchell Library, SLNSW

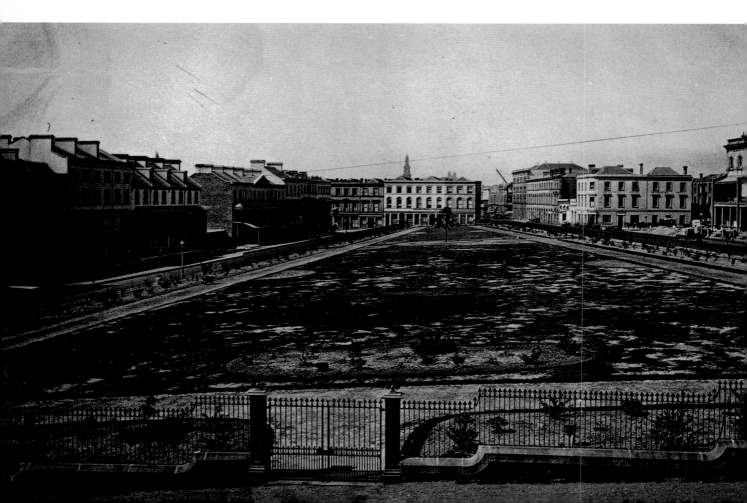

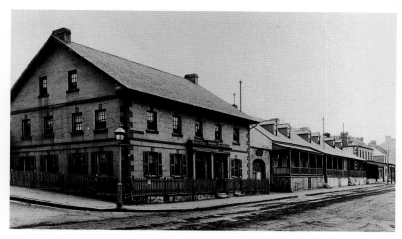

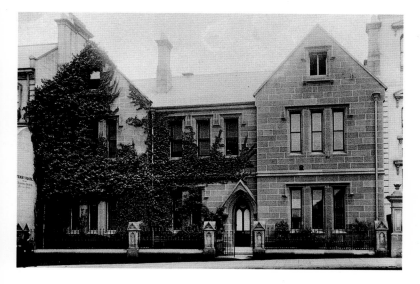

Above

Princes Street

Sydney

Princes Street and its houses were demolished for Sydney Harbour Bridge in 1927. The houses shown were sold for five shillings each on condition that purchasers removed all building materials from the site.

Photograph: Royal Australian Historical Society

Left

St Philip's Church of England Rectory

York Street, Sydney

Built in 1859, with substantial additions to the rear of the building by Edmund Blacket in 1874. This rectory, built as a replacement for an earlier one in Gresham Street, was located between Margaret and Jamison Streets and in turn became redundant when a new rectory was built to the north of the church in 1901. All three rectories have been demolished.

Photograph: SPF, Mitchell Library, SLNSW

Top

House

5 Harrington Street, Sydney

Built before 1848 and occupied at that time by Joseph Fowles, artist whose *Sydney in 1848*, published 1848-50, provides an extraordinary visual record of the city's mid-nineteenth century streetscapes. The house was demolished in the early 1900s.

Photograph: Royal Australian Historical Society

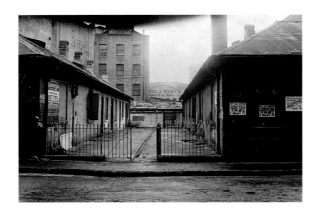

Queens Court
George Street, Sydney

Located between George and Pitt Streets, near Bridge Street, this court of eighteen terraces was described in the 1859 Inquiry into the Condition of the Working Classes as overcrowded substandard housing, without adequate ventilation, running water, with open sewers and one privy per six dwellings. Demolished folowing the construction of Dalley Street.

Photograph: Royal Australian Historical Society

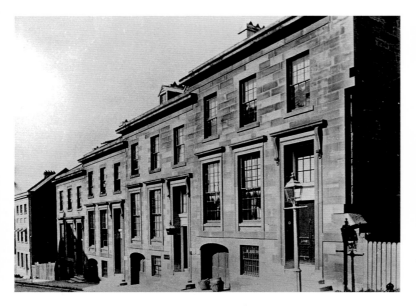

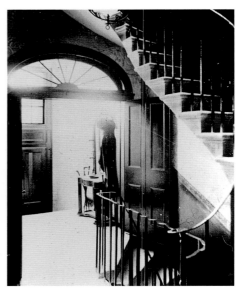

Above and right

Four Terrace Houses
Jamison Street, Sydney

An elegant row of town houses built c.1840 for the Reverend John Dunmore Lang and used as his residence and his Australian College. Located near the present Scots Kirk, it was derelict by 1937 and subsequently demolished. Used for many years as a car parking lot, a hotel is currently under construction on the site.

Photographs: (above) Kerry & Co; Mitchell Library, SLNSW; (right) Kerry & Co; Royal Australian Historical Society

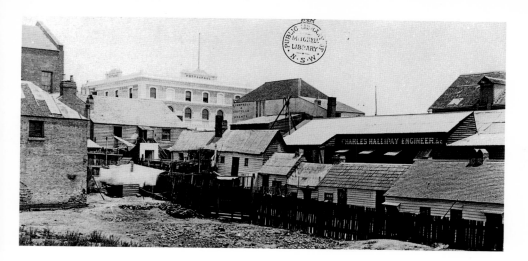

Above

Dwellings

Turners Lane, Sydney

The five two-roomed houses and four one-roomed shanties existing in Turners Lane (north off Erskine Street near Sussex Street) in 1876 had six-foot (1.8m) ceilings, faced onto swampy land, their inhabitants overpowered by the stench from Darling Harbour. They were typical of the myriad substandard mid-nineteenth century dwellings tucked away in back lanes and courts and inhabited by workers forced to live close to their place of employment owing to the lack of public transport.

Photograph: SPF (BM), Mitchell Library, SLNSW

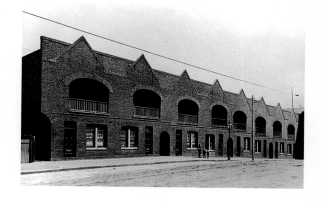

Above right

Terraces

1-15 Day Street, Sydney

Built in 1905 by the Sydney Harbour Trust to replace existing substandard housing, this workers' terrace was resumed by the Department of Main Roads in 1969 and subsequently demolished for an expressway.

Photograph: GPO 1, Mitchell Library, SLNSW

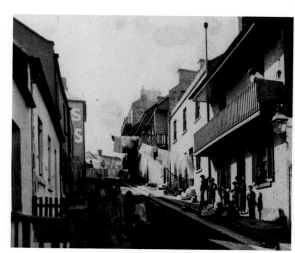

Right

Clyde Street

Millers Point

Early in the first decade of the twentieth century, houses in Clyde Street and its parallel streets, Wentworth and Unwin, all running from the end of Argyle Street south-west down to Darling Harbour, were demolished for the construction of Hickson Road and new wharves.

Photograph: Mitchell Library, SLNSW

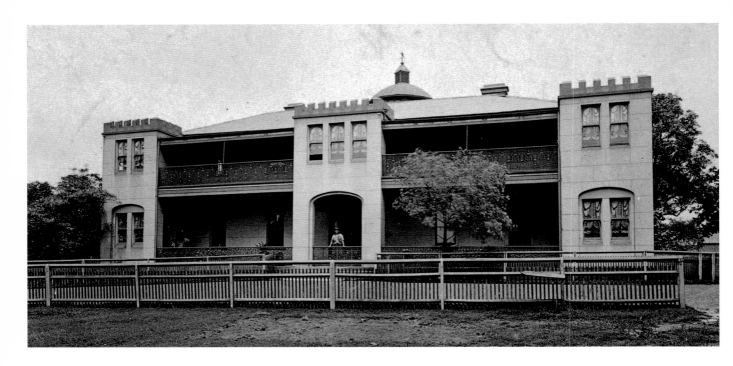

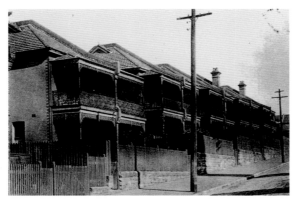

Above

Ultimo House
Ultimo

Built for John Harris, c.1805 with later additions by Francis Greenway, architect, and remodelled later in the century, the house remained in the ownership of the Harris family until the late nineteenth century. Located in the vicinity of present Thomas Street, the house was purchased by the government in 1910 for educational purposes and demolished c.1932 for Sydney Technical College.

Photograph: Royal Australian Historical Society

Above

Smooges Terrace
Jones Street, Pyrmont

An impressive streetscape of late nineteenth century semi-detached houses located between Bowman and John Streets, demolished in 1980, despite local protest, for a factory car park.

Photograph: CSR Ltd

Right

Rose Cottage
95 John Street, Pyrmont

Built in c.1840 for Thomas Day, the cottage was demolished for a railway goods line in 1916.

Photograph: SPF (BM), Mitchell Library, SLNSW

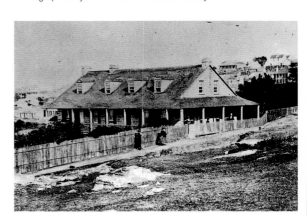

EAST AND SOUTH-EAST

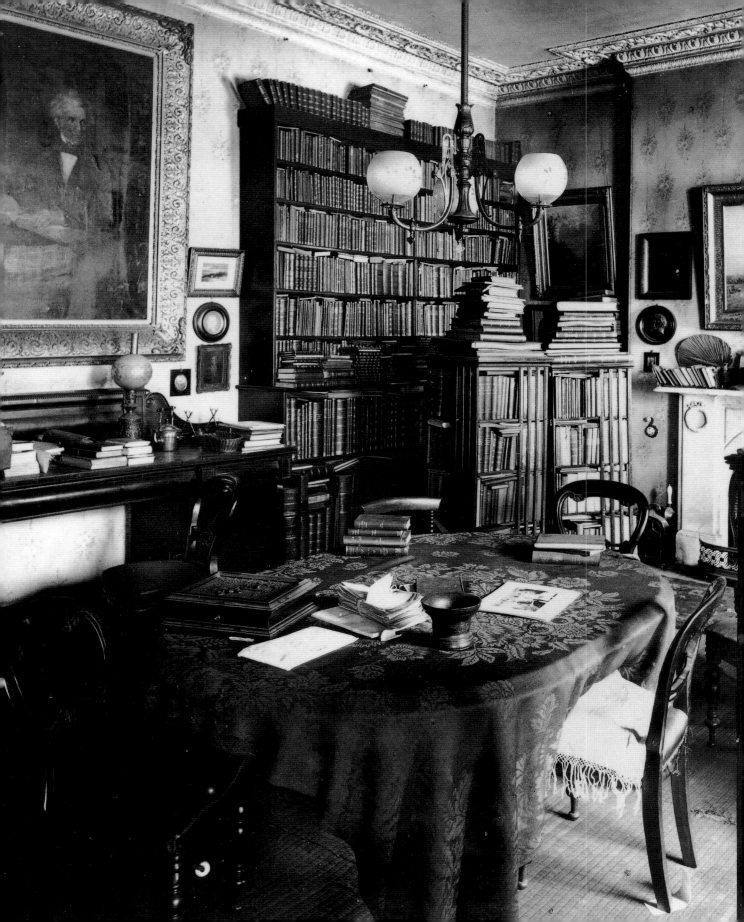

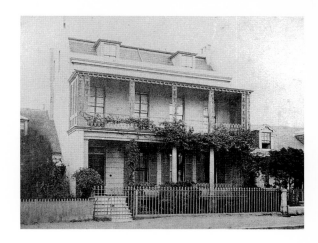

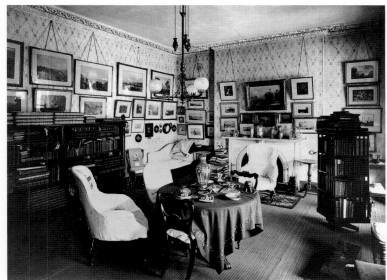

David Scott Mitchell's house
17 Darlinghurst Road, Darlinghurst

The residence, from the early 1870s until his death in 1907, of David Scott Mitchell, one of Australia's greatest benefactors. Here, Mitchell amassed an unsurpassed collection of paintings, books, manuscripts and maps relating to Australia and the Pacific which he bequeathed to the Public (now State) Library of New South Wales, on condition that a new building was erected for its accommodation. The Mitchell Library is acknowledged as one of the world's outstanding national collections. The site of Mitchell's house, near the junction of Darlinghurst and Macleay Streets, is now occupied by shops.

Photographs: Mitchell Library, SLNSW

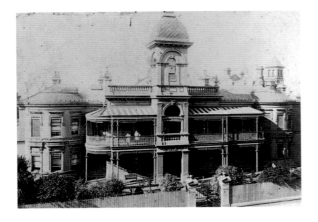

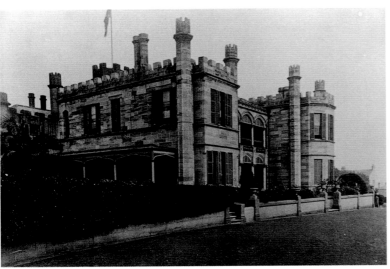

Above

Granthamville (later Grantham)
Wylde Street, Potts Point

Originally an early Gothic house 'Caleb's Castle' or 'The Pepper Pot' built c.1838 for Caleb Wilson, ironmonger, possibly to a design by Francis Greenway, and with substantial additions, in 1871, by Edmund Blacket, architect, for Henry Carey Dangar. Located near present Grantham Street, the house was demolished for flats in 1937.

Photograph: Private collection

Right

Campbell Lodge
Wylde Street, Potts Point

Built c.1850 with later additions by John Frederick Hilly, architect, for himself, the house was demolished for flats in 1909.

Photograph: Sydney City Council Archives

Left

Maramanah
Darlinghurst

Built in c.1882 for E. J. Sparke incorporating an earlier cottage, its later occupation by the Hollander family is vividly captured by Robin Dalton, in her *Aunts up the Cross* (1998). Located on the corner of Elizabeth Bay Road and Macleay Street, Maramanah was resumed c.1949 by the Council of the City of Sydney, demolished in 1954 and the site incorporated into Fitzroy Gardens.

Photograph: SPF (BM), Mitchell Library, SLNSW

Below

Goderich Lodge
Darlinghurst

Built in 1832 for Thomas Macquoid, Sheriff of NSW, to a design of John Verge, architect. Located at the top of William Street, it was demolished c.1910. A hotel now occupies its site.

Photograph: Sydney City Council Archives

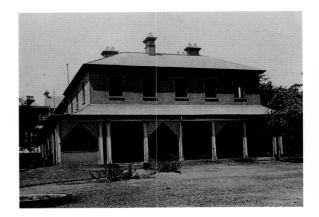

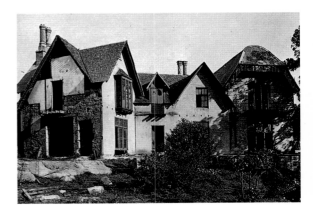

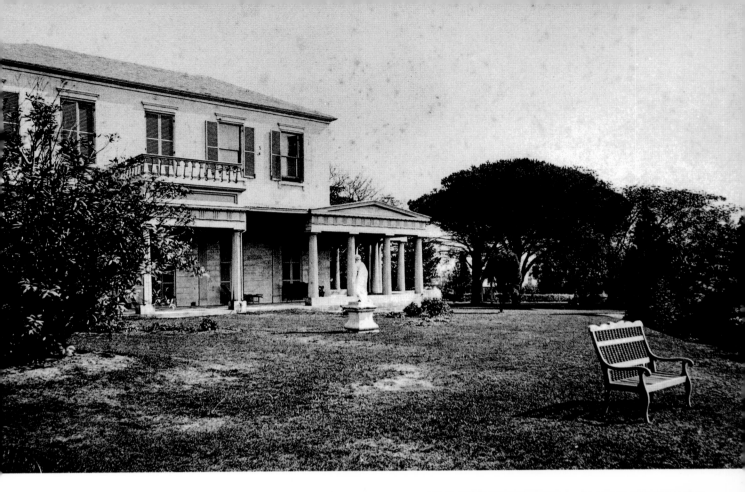

Above

Craigend
Darlinghurst

Designed and built in 1829 by Thomas Mitchell, explorer and Surveyor-General of NSW, and occupied by him until the 1840s. Located in the vicinity of present Caldwell and Surrey Streets, the house became a private hospital in the late nineteenth century, and was used as a boarding house prior to its demolition in 1922 for a residential subdivision.

Photograph: SPF (BM), Mitchell Library, SLNSW

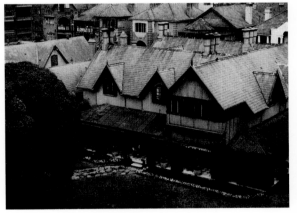

Right

Larbert Lodge
46 Macleay Street, Potts Point

Built in the 1830s to a pattern-book design for Campbell Drummond Riddell, Colonial Treasurer, the house was demolished in the late 1930s and replaced by flats.

Photograph: John Phillips; SPF, Mitchell Library, SLNSW

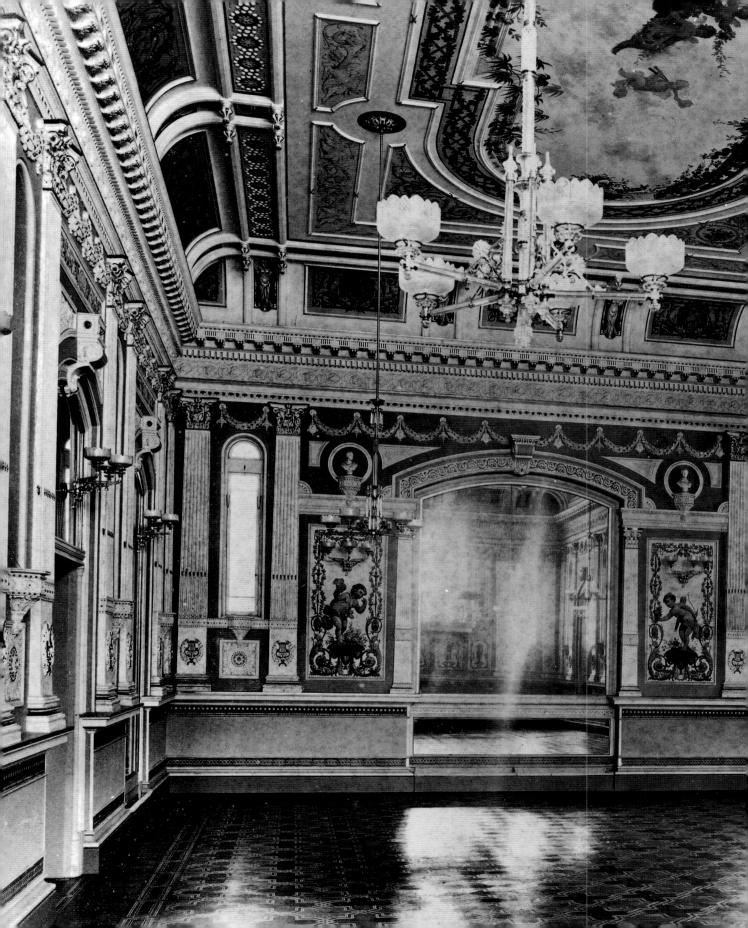

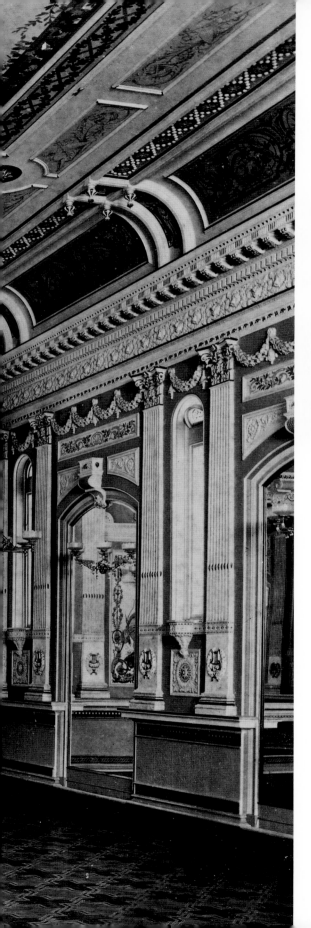

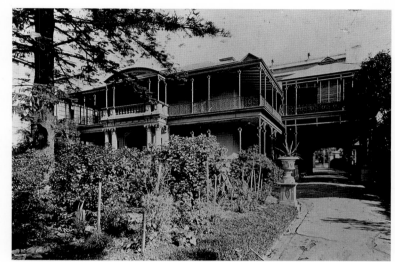

Chatsworth

22 Wylde Street, Potts Point

Originally Tor Cottage built in the 1840s with a storey added in the 1850s, Chatsworth was acquired in 1878 by Charles James Roberts, publican, politician and Mayor of Sydney. Roberts made substantial additions to the house including a ballroom lavishly decorated by Augusto Lorenzini. Occupied by Sydney Church of England Girls Grammar School (SCEGGS) from 1896 to 1900, Chatsworth was demolished in 1921 and replaced by flats of the same name which in turn were demolished in February 1999.

Photograph: (above) SCEGGS, Darlinghurst; (left) Charles Bayliss; Historic Houses Trust of NSW

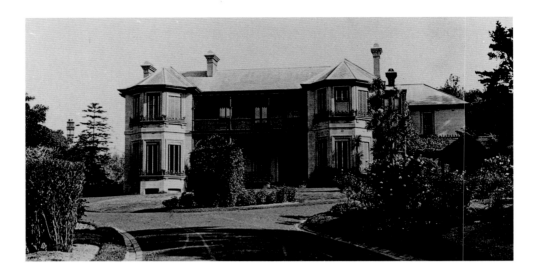

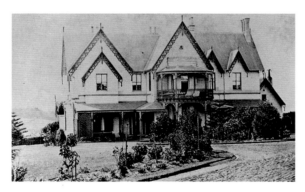

Merioola
Edgecliff Road, Edgecliff

Built in 1859 for John Edye Manning and remodelled and extended c.1912 for Arthur Wigram Allen who lived there from 1911 until his death in 1941. The garden was partially demolished c.1920 for residential subdivision and the construction of Rosemont Avenue. Occupied in the late 1940s by artists, sculptors and designers, later renowned as the 'Merioola Group', the house was demolished for flats in 1952.

Photographs: Arthur Wigram Allen; Allen Family Albums, Mitchell Library, SLNSW

Orielton
Edgecliff Road, Edgecliff

Built in the 1860s, and later the residence of Sir Alfred Stephen, Chief Justice and Lieutenant-Governor of New South Wales. The house was demolished and replaced by tennis courts after World War I.

Photograph: SPF (BM), Mitchell Library, SLNSW

Wallaroy
Edgecliff Road, Woollahra

Built in 1859 for Sir William Manning and demolished for residential subdivision before 1949. Another example of the architectural diversity of the mansions built along Edgecliff Road.

Photograph: SPF (BM), Mitchell Library, SLNSW

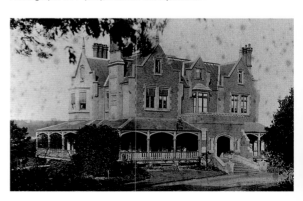

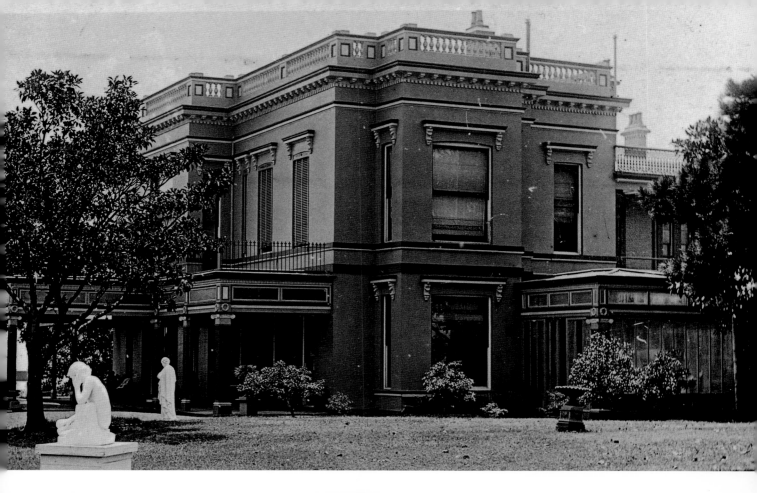

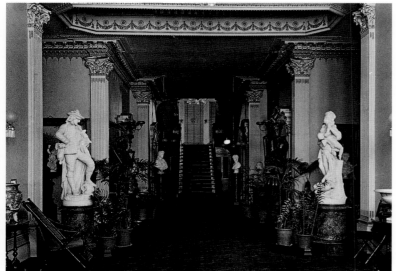

Above and left

Etham

Darling Point Road, Darling Point

Built in 1869 for James Sutherland Mitchell, a partner in Tooth's Brewery, who subsequently acquired two large adjoining properties. In the early twentieth century, the estates were subdivided forming Etham Avenue and Sutherland Crescent. The house was demolished for further subdivision in the 1920s.

Photograph: (above) SPF (BM), Mitchell Library, SLNSW; (left) entrance hall, Arthur Wigram Allen; Allen Family Albums, Mitchell Library, SLNSW

Retford Hall

Thornton Street, Darling Point

Built in 1866 by Edmund Blacket, architect, for
Anthony Hordern, whose large retail stores (now
demolished) were once synonymous with Sydney.
The house, with additions in 1920 by Morrow and
de Putron, architects, remained in family ownership
until sold and demolished in 1967 for home units.

Photograph: Clive Lucas; National Trust of Australia (NSW)

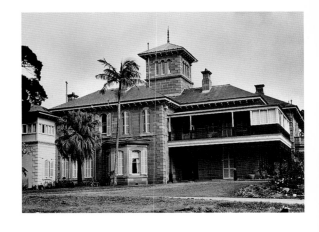

Left and below

Brooksby

45 Ocean Street, Double Bay

A plain Georgian-style two-storey box, built in 1838
for James Maclehose, publisher, and purchased and
named in the 1850s by Robert Johnson, solicitor,
who added single-storey wings and established its
extensive garden and grounds. A subsequent owner
added a two-storey rear wing and a massive porte-
cochere, (possibly c.1913 by Wardell and Denning,
architects). The lower garden fronting Ocean Avenue
was progressively subdivided; the house was
demolished for home units in 1965.

Photographs: Harold Cazneaux, Historic Houses Trust of NSW

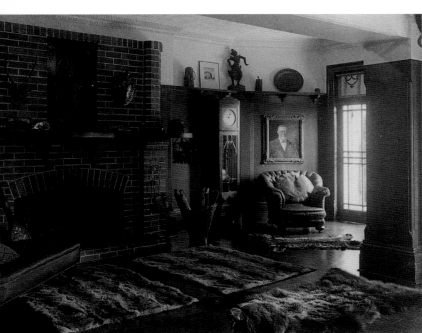

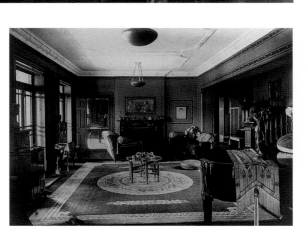

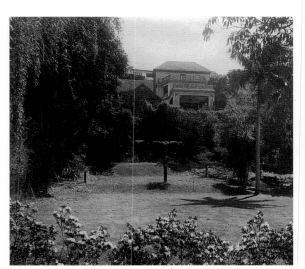

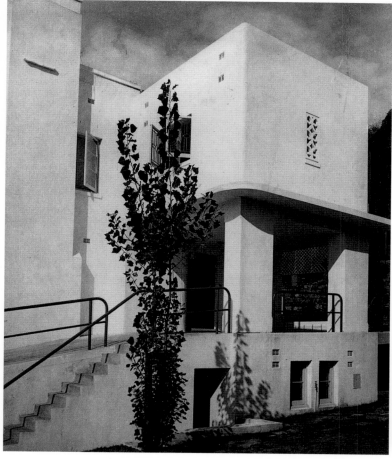

Left

Cotway

553 New South Head Road, Bellevue Hill

Designed by F. Glynn Gilling, architect, in the 1930s for the Field family, Cotway was subsequently acquired by Cranbrook College for use as boarders' accommodation. An important example of the 1930s International style, the house was demolished in 1990.

Photograph: Cecil W. Bostock; from the collection of Douglas Gilling

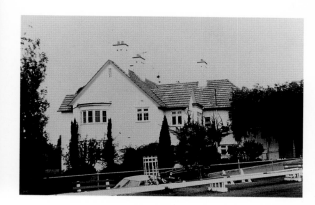

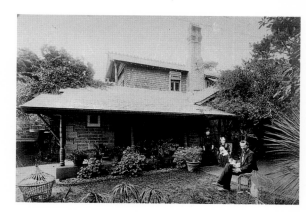

Above right

Royle House (formerly Yandooya)

65 Cranbrook Road, Bellevue Hill

Built in c.1914 by Manson and Pickering, architects, for Prosper Williams, it was acquired by Scots College in 1949 and demolished for a new resources block in 1981.

Photograph: National Trust of Australia (NSW)

Right

Cranbrook Cottage

New South Head Road, Bellevue Hill

Built in 1874 by J. Horbury Hunt, architect, for himself. Hunt conducted his practice from his studio on the upper floor which housed his remarkable collection of 4000 books on architecture. Demolished in 1925 for the widening of New South Head Road.

Photograph: SPF, Mitchell Library, SLNSW

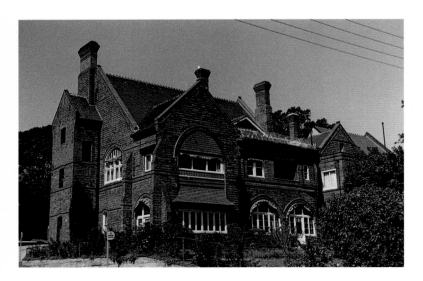

St Mervyns
New South Head Road, Double Bay

Built in 1887, to the design of J. Horbury Hunt, architect, for Edward Percy Simpson, solicitor, who lived there until 1917. Subdivision began in 1924 and St Mervyns Avenue formed. The house was demolished for home units in 1965.

Photograph: Ian G. Scott; Woollahra Library, Local Studies Collection

Below left

Woollahra House
Point Piper

Built in 1883 for William Cooper who had purchased the Point Piper estate from his father Sir Daniel Cooper in 1882. Occupied by the Cooper family until 1888, the mansion, its grounds reduced to two acres, was sold in 1899 to Thomas Longworth, a mine owner, who died there in 1927. Located near present Longworth Avenue, the house was demolished for further residential subdivision in 1929. Its entrance lodge survives as Rose Bay Police Station; its stables, converted to apartments, survive in Wyuna Road.

Photograph: *Our Beautiful Homes*, c.1907

Below

House
20 Wyuna Road, Point Piper

Built in 1962 for the Hauslaib family, to a design by Arthur Baldwinson, architect, the house was sold and subsequently demolished in 1997-98 for a new residence.

Photograph: Baldwinson Collection, Mitchell Library, SLNSW

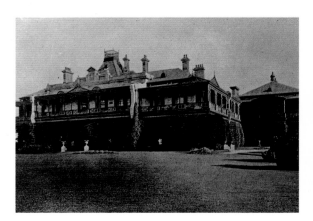

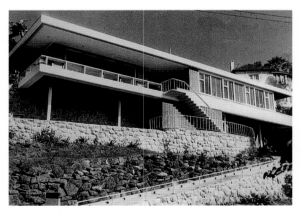

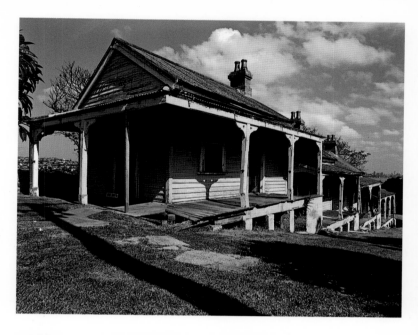

Right

Terraced Cottages

HMAS Watson, Watsons Bay

Built in 1894 as single officers' quarters, possibly to a design of James Barnet, architect, this terrace of four cottages was listed as a heritage item in the Woollahra Local Environment Plan no. 27, included on the Register of the National Estate and classified by the National Trust of Australia (NSW). Dilapidated and restoration considered to be uneconomical, the terrace, stripped of its decorative cast iron verandah railings, was demolished by the Commonwealth Government in 1993.

Photograph: Woollahra History and Heritage Society; Woollahra Library, Local Studies Collection

Right and below right

Clovelly

Watsons Bay

Built for Thomas Watson c.1836 with additions for Hannibal Hawkins Macarthur in the 1840s. Later owned by Henry Watson Parker and Sir John Robertson, premiers of New South Wales, the latter living there from 1878 until his death in 1891. The house was declared unfit for human habitation in 1902, demolished in 1903 and the site purchased for a public park in 1906.

Photograph: (right) GPO 1, Mitchell Library, SLNSW; (below right) Royal Australian Historical Society

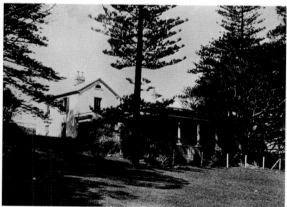

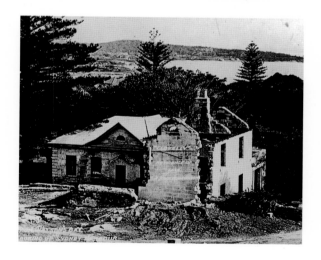

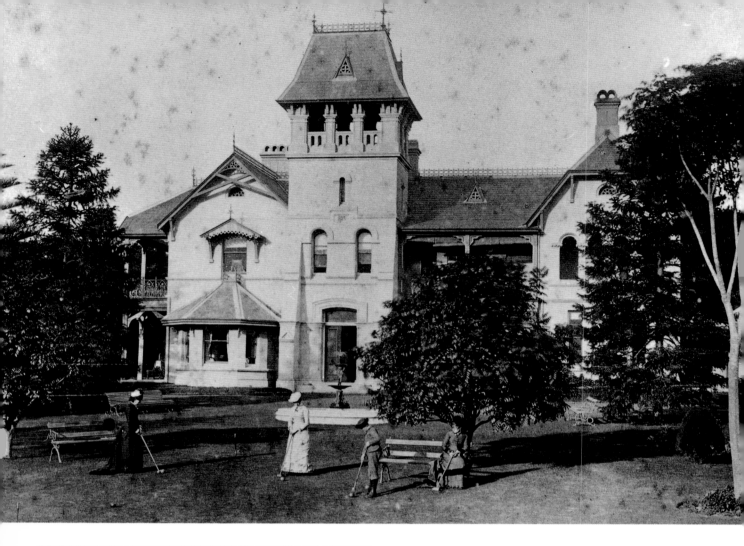

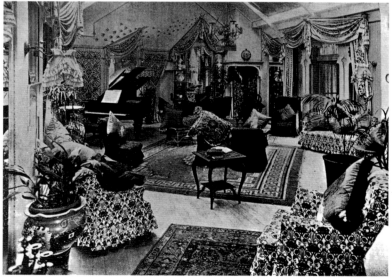

Above and left

Kioto (formerly Llandaff)

Botany Street, Waverley

Built in 1876 for J. H. Newman with alterations and redecoration for Edmund Playfair in c.1904, the house was demolished for flats in the 1940s. The gateposts remain.

Photograph: (above) SPF (BM), Mitchell Library, SLNSW; (left) music room: *Our Beautiful Homes*, c.1907

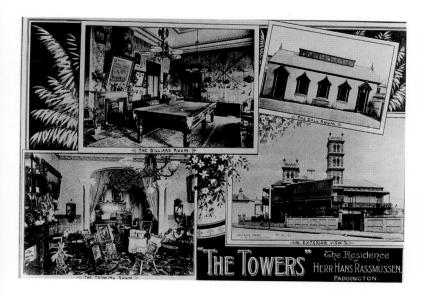

Above

The Towers
Gordon Street, Paddington

Built in 1888 for Herr Hans Rasmussen and purchased in 1903 by the Sisters of Charity, the house was demolished for a new convent in 1969.

Photograph: G. Robertson, *Beautiful Sydney*, 1895. Mitchell Library, SLNSW

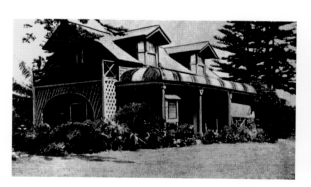

Below

Waverley House
Old South Head Road, Waverley

Built in 1827 for Barnett Levey, theatrical entrepreneur. After a succession of owners, St Gabriel's School opened there in 1893, later moving to Preston in Birrell Street. Located on the southern side of Old South Head Road near its intersection with Bondi Road, the house was demolished in 1904 and a new house built on the site.

Photograph: Josephine E. Foster; SPF (BM), Mitchell Library, SLNSW

Below left

The Homestead
Bondi

Built by 1847 as Bondi Lodge for Edward Smith Hall, editor of the *Sydney Monitor*, this early Bondi residence was demolished for residential subdivision after 1920.

Photograph: Waverley Library, Local Studies Collection

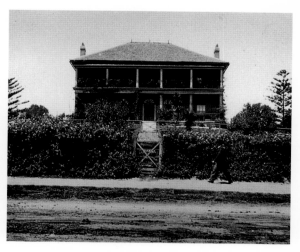

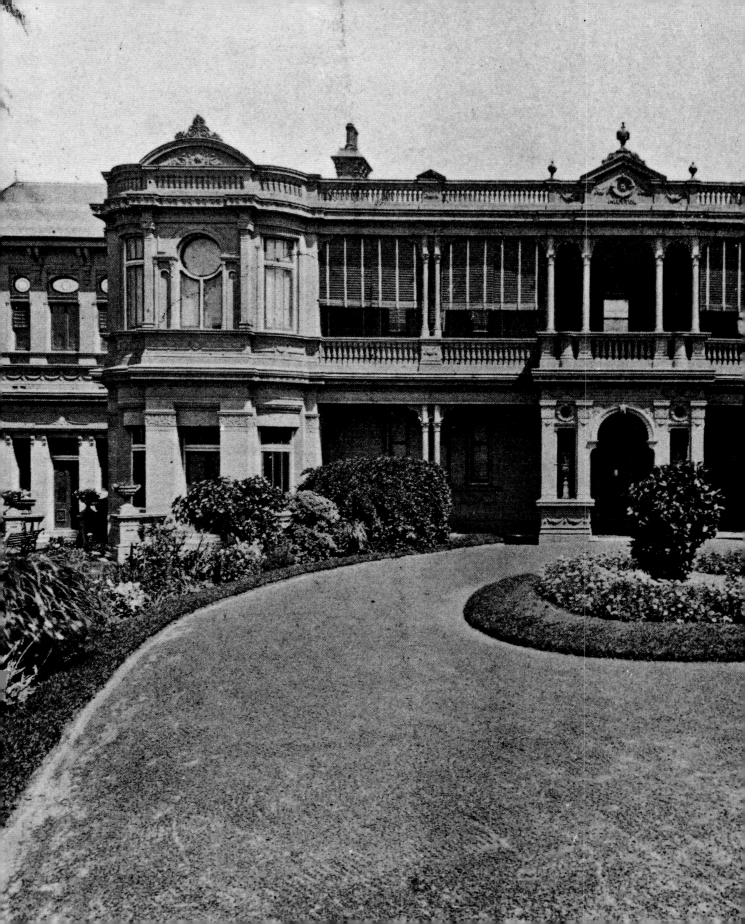

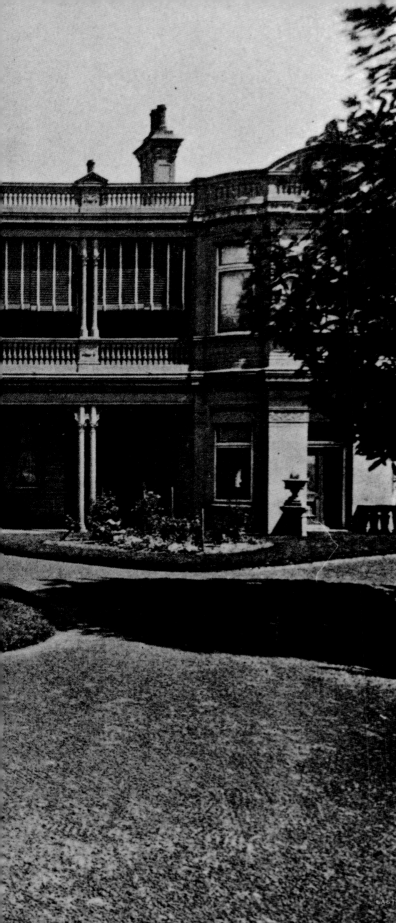

Preston

Birrell Street, Waverley

Built in the late 1880s, with later additions for Richard Craven, mine owner, and subsequently St Gabriel's School. Demolished by Waverley Bowling Club in 1966.

Photograph: (above) Jill Crossley; National Trust of Australia (NSW); (left) *Our Beautiful Homes*, c.1907

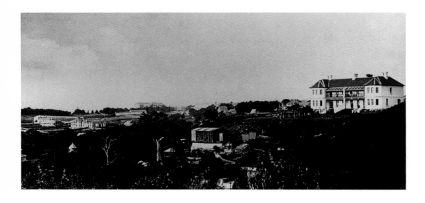

Medina and Warawee

63-65 St Marks Road, Randwick

An impressive pair of large semi-detached houses built c.1884 by George Wall, customs agent and sometime Mayor of Randwick, who resided in Medina. Demolished, despite local protest, in c.1981 for home units. One of a number of heritage-listed houses bordering Glebe Gully that were demolished. The Glebe Gully with its pockets of rainforest, owned by the Anglican Church since 1857, was itself threatened in 1980 when sold to developers who proposed to erect 128 units on the site. Residents' action groups and the Randwick Historical Society, supported by nine trade unions were successful in saving most of the gully.

Photograph: Bowen Library, Randwick

Left and below

Mundarrah Towers

Clovelly Road, Clovelly

Built c.1860 for Dr Dickson, with later additions possibly for Samuel Bennett of the *Australian Town and Country Journal*. The house was demolished for a hotel in 1923.

Photographs: SPF (BM), Mitchell Library, SLNSW

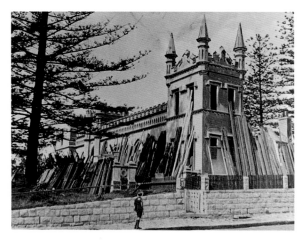

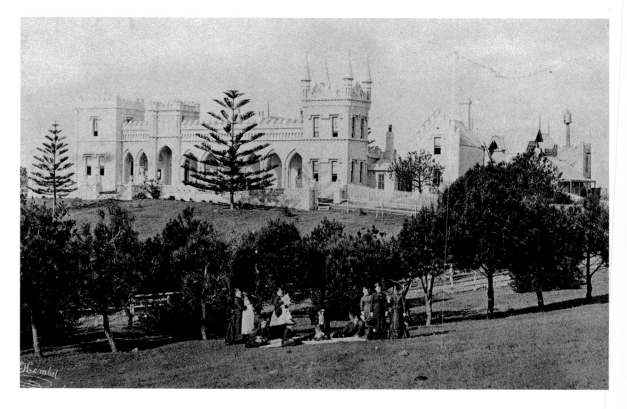

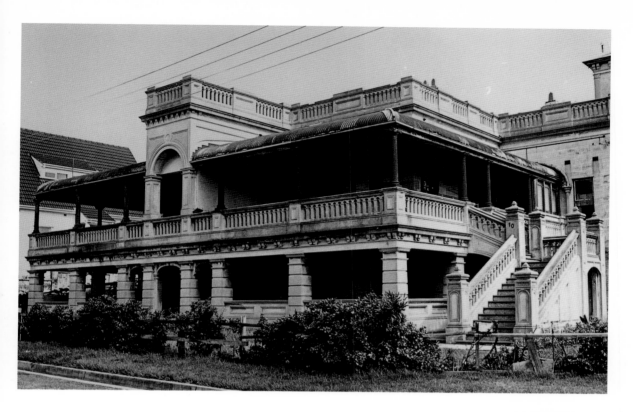

Cliffbrook

Gordon Street, Coogee

Built in 1873 for John Thompson, Mayor of Randwick, with lavish interior decoration. Owned in the 1890s by pastoralist George Hill, and by Sir Denison Miller, first Governor of the Commonwealth Bank from 1915 until his death in 1923, the house was demolished for town houses in 1976.

Photograph: (above) Richard Temple-Watt, National Trust of Australia (NSW); (right) Sheridan Burke

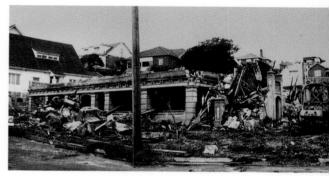

Arara

18 Silver Street, Randwick

Built c.1900 by William Duggan, a well-known Randwick racing identity, the house was subsequently acquired by Randwick Municipal Council, for use as a library. When restoration was considered uneconomical, Arara was demolished in 1977 for a car park.

Photograph: National Trust of Australia (NSW)

Redwood

252 Gardeners Road, Rosebery

A fully imported prefabricated house, built in 1916 by
the Californian Redwood Association for the
promotion of Californian Redwood. An early
introduction and important example of the California
Bungalow style, the house was demolished for home
units in 1968.

Photograph: National Trust of Australia (NSW)

Twin Palms Oasis

23 Byrnes Street, Botany

A fibro-clad early timber cottage, the enthusiastic
embellishments of its exterior, interiors and grounds
reflecting the creative talents of its former owner.
Deliberately vandalised, its interiors wrecked, the
house remains, its future uncertain.

Photograph: Beverley Clay; Museum of Applied Arts and Sciences

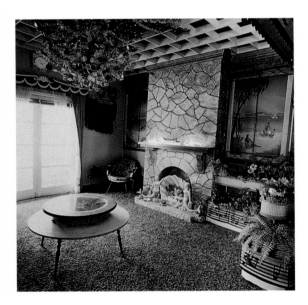

SOUTH AND
SOUTH-WEST

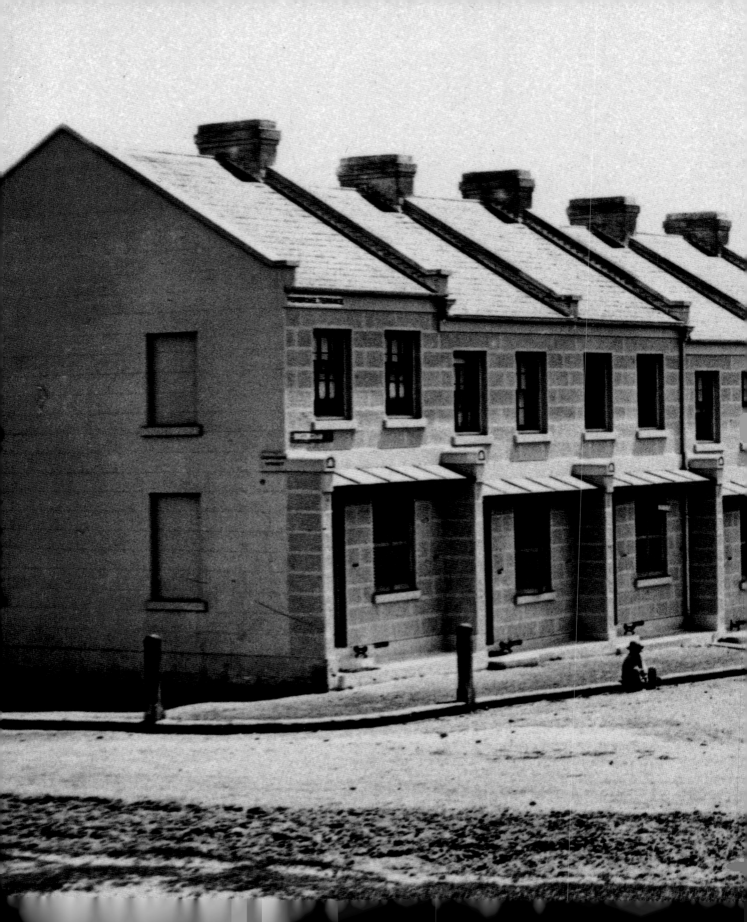

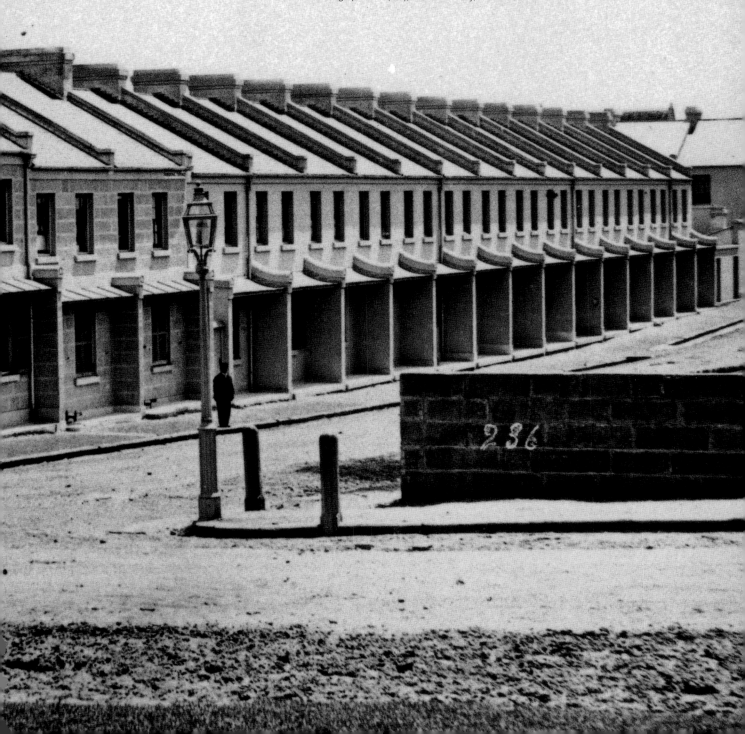

Terraces
Buckingham Street, Surry Hills

Photographed from Cleveland Street in 1871 soon after completion of the terraces. This late-nineteenth century streetscape was destroyed in the 1990s when fifteen of the twenty-one houses (nos. 61-89) were demolished for commercial development. The six houses (from left) remain.

Photograph: SPF (BM), Mitchell Library, SLNSW

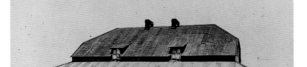

House

24 Morehead Street, Redfern

A Gothic weatherboard worker's cottage built in the 1870s and a rare example in Redfern of its type. Sold to developers in 1994, the initial Development Application for multi-storey units was a catalyst for resident action to conserve the character of the area. Low-rise units now occupy the site.

Photograph and information: Bruce Baskerville

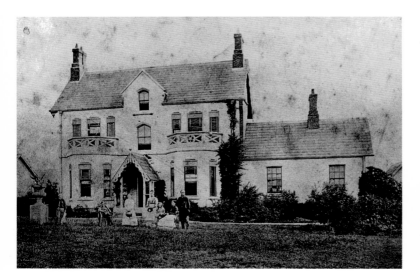

Top

Calder House

Redfern

Built in the late 1820s for James Chisholm, and used as a school from 1855 until its purchase in 1878 by the government. Located opposite Redfern station near present Wilson Street, the house was demolished in 1924.

Photograph: Royal Australian Historical Society

Above

St Paul's Church of England Rectory

Cleveland Street, Redfern

Built c.1870, one of the many houses demolished in Redfern c.1910 for railway extensions.

Photograph: SPF (BM), Mitchell Library, SLNSW

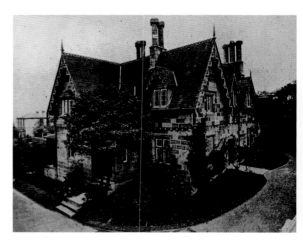

Above

The Retreat

Burren Street, Newtown

Built c.1845 for John Blackman, auctioneer. Later known as Twickenham, it was acquired by the Sydney Nursery Training College and subsequently demolished in 1971 for a new building.

Photograph: *Sunday Times*, 1907

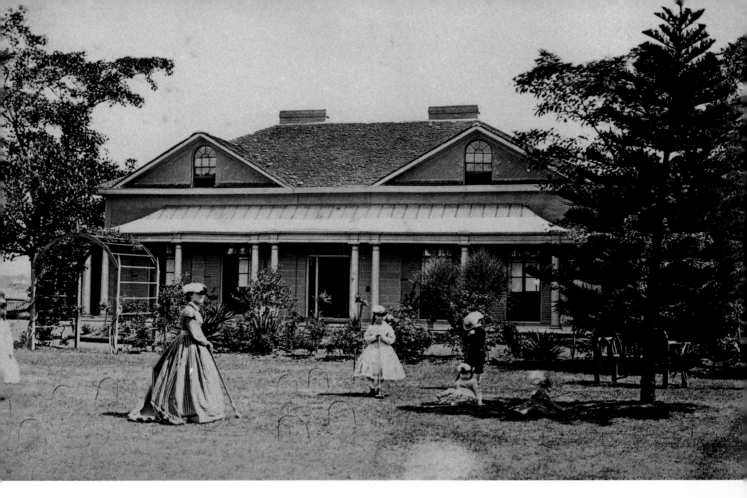

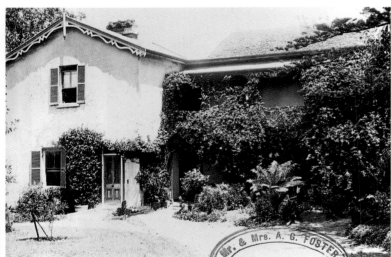

Above

Holmwood

King Street, Newtown

Built c.1841 for merchant William Fanning and owned from 1859 by politician and merchant, James Dickson, and his family. One of the early houses built on estates along King Street. In 1890, the property was sold and subdivided; the house, set back between present Holmwood and Dickson Streets was demolished soon after.

Photograph: Mitchell Library, SLNSW

Left

Reiby House

Station Street, Newtown

Built in the 1840s for Mary Reibey, emancipist and astute businesswoman. Following her death in 1855, part of the estate was subdivided and from 1880 the house was used for a school. Purchased by the City of Sydney Council c.1966 and demolished for high-rise home units.

Photograph: Josephine E. Foster; Royal Australian Historical Society

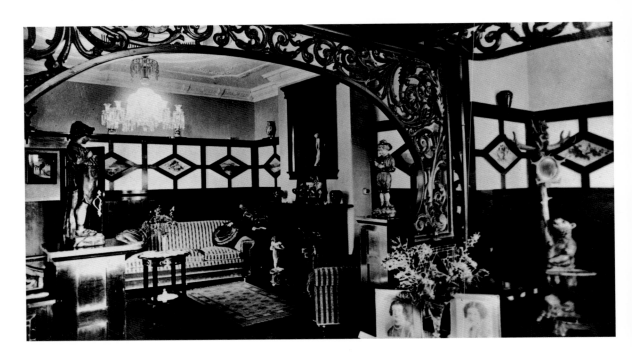

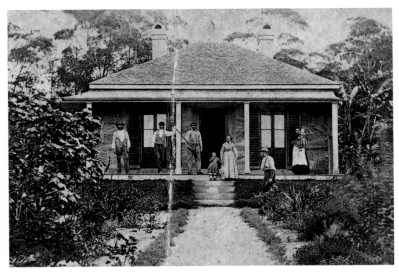

Top and above

Maudeville
22 Newington Road, Marrickville

Demolishing his vernacular cottage c.1916, A. P. Donney built a new house on the site which adjoined his brass foundry. The house, stripped of its decorative interiors, survived as a factory office until the mid-1990s when it was demolished for town houses.

Photographs: (top) Melba Studios, Sydney; Marrickville Library Services, Local Studies Collection; (above) *Diamond Jubilee Souvenir of Marrickville*, 1922.

Above

Stone Cottage
Harriet Street, Marrickville

Stone Cottage was built c.1864 for James and Ann Meek, who first settled in the district in 1839 and where James ran large market gardens until his death in 1881. In the late nineteenth century the market gardens were subdivided into building allotments and the house, located in what is now Harriet Street, was subsequently demolished. James Meek junior's house, Myrtle Grove, built in Marrickville in 1887, survives.

Photograph: SPF (BM), Mitchell Library, SLNSW

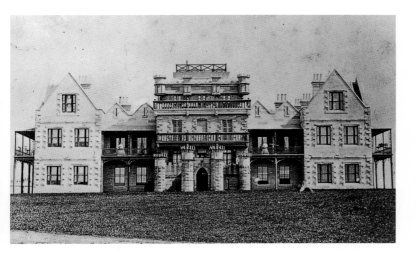

The Warren

Marrickville

Built in the 1850s for Thomas Holt, with later substantial additions by G. A. Mansfield, architect. The mansion, its grounds reduced by subdivision, was used from c.1883 as a convent, and during World War I as an artillery camp. Located in the vicinity of present Mansion Street, it was resumed by the government in 1919, demolished in 1922 and houses for returned soldiers built on the site.

Photograph Private collection, from Marrickville Library Services, Local Studies Collection

Below

Kirnbank

Bonar Street, Arncliffe

Originally a modest two-storey house built c.1893 by Justin McSweeney, an engineering contractor. Upon his marriage in 1898, McSweeney added a substantial three-storey wing including a lavishly decorated ballroom. Later occupied by his sister and niece and from 1940 to 1954 tenanted by the McManus family. Sold c.1955, the house was used for a factory office until its demolition in the mid-1980s for factory extensions.

Photograph: Rockdale City Library, Local Studies Collection

Brockleigh

86-90 Illawarra Road, Marrickville

Built in 1886, possibly for Theodore Anthony Clark, brother of the retailer Henry Marcus Clark, the house was owned for part of the late nineteeenth century by merchant George Brock. Seemingly protected by an Interim Conservation Order of 29 May 1987, demolition of the house began on 13 June. Demolishers, warned off by police, returned to the site on 15 June and razed the house. This and the demolition of nearby Rose's Emporium prompted stronger penalties for demolishers and/or developers who deliberately flouted the law.

Photograph: National Trust of Australia (NSW)

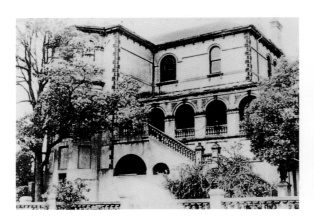

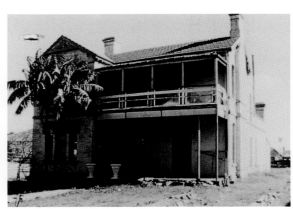

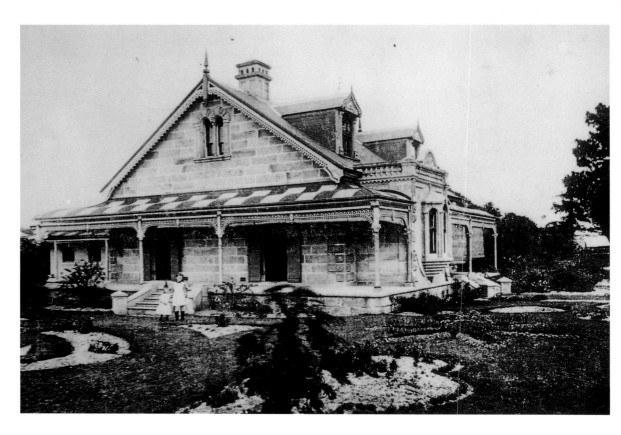

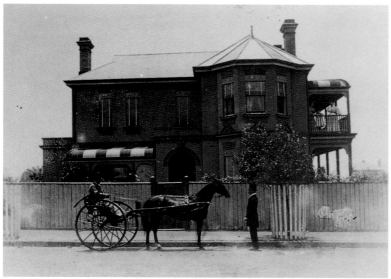

Rosevale Villa

Rockdale

Built in 1873 by William John Iliffe, next to his Rosevale Garden Nursery which was located between present Bestic and Bryant Streets. The house was demolished in 1962 for a service station.

Photograph: SPF, Mitchell Library, SLNSW

Left

Devaran

Belgrave and Kensington Streets, Kogarah

Built in the 1880s for Dr James Lamrock, a founder of St George Cottage Hospital, it continued as a residence and surgery in the twentieth century, later becoming a nursing home. Sold to developers in 1996 and, despite strong local protest, demolished in 1997. The site is currently vacant.

Photograph: Kogarah Historical Society

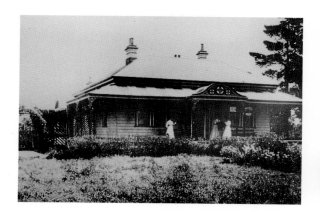

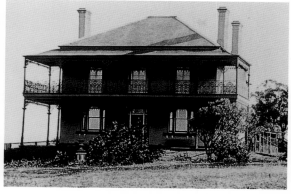

Above left

Joyholme
1 Plimsoll Street, Sans Souci

Built as Denbeigh in 1887 for William Rust, its name was changed by a subsequent owner. The house was demolished for town houses in 1986.

Photograph: SPF (BM), Mitchell Library, SLNSW

Above

Gannon Grove
Croydon Road, Hurstville

Built in 1882 for Alfred Gannon, whose father, Michael Gannon, in 1850, purchased most of the land which now forms the suburb of Hurstville. The house was demolished for flats in 1937.

Photograph: Hurstville City Library, Local Studies Centre

Above

The Hut
273 Dora Street, Hurstville

Built as Glenroy in the first decade of the twentieth century and purchased c.1911 by Alice Lewis, whose husband George was a plasterer. Occupied from 1917 to 1960 by the Lewis family, the house with its castellated additions and other embellishments, was incongruously renamed The Hut. Its large grounds previously subdivided, the house was sold in 1960 and survived until the early 1990s.

Photograph: National Trust of Australia (NSW)

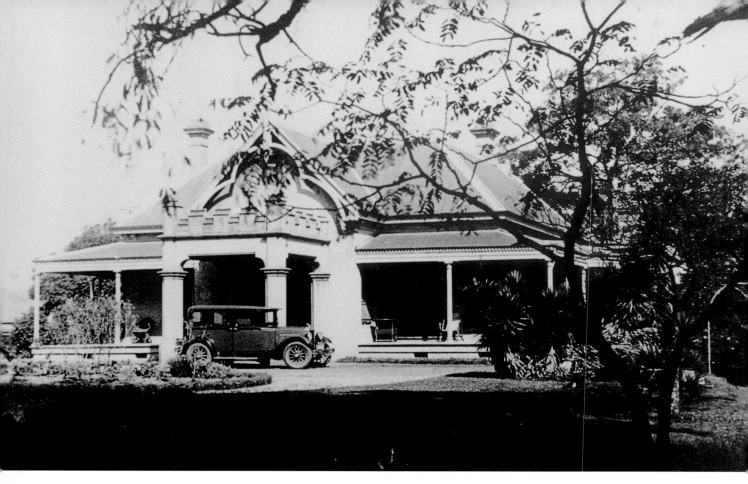

Above

Kenilworth

Penshurst Street and Forest Road, Penshurst

Built c.1891 for William de Lisle Roberts, Government Assayer, the house, which remained in family ownership until well into the twentieth century, was demolished in the 1960s for Penshurst Girls High School.

Photograph: Hurstville City Library, Local Studies Centre

Above right

Bridge Cottage

Tom Ugly's Bridge, Sylvania

Built 1860-61 for Thomas Holt and known as Punt House, its name change possibly coincided with the construction of Tom Ugly's Bridge. Located at the bridge's southern approach and said to be one of the earliest houses in the Sutherland Shire, this once familiar landmark was demolished for road widening in the late 1970s or early 1980s.

Photograph: National Trust of Australia (NSW)

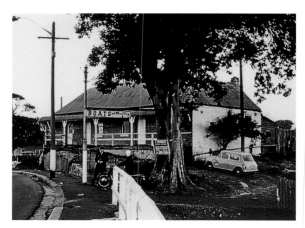

Above

House

135 Acacia Road, Kirrawee

Built in 1955 for Aileen and Harold Holden, based on Aileen's floor plan from which drawings were prepared by Grace Bros Home Building Service. A typical example of the myriad fibro houses once predominant in Sydney's new post-war suburbs and now disappearing rapidly from their streetscapes. Demolished together with surrounding houses c.1990 for a large home unit development.

Photograph: Aileen and Harold Holden

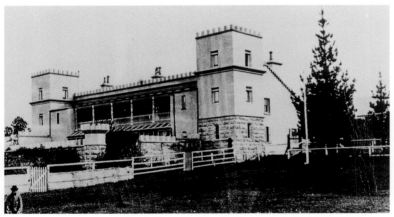

Left

Sutherland House

Sutherland

Built c.1878 by Thomas Holt, on the foreshores of Sylvania between Sandy Point and Horse Rock Point; later occupied by his son Frederick and sold c.1908. It was deliberately burnt in 1918.

Photograph: Sutherland Shire Library, Local Studies Collection

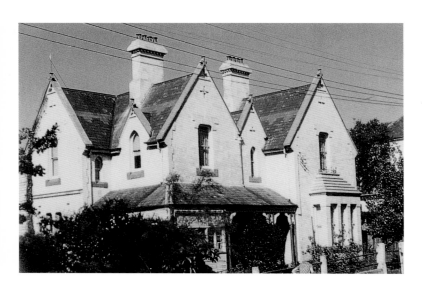

St Andrew's Rectory

Henson Street, Summer Hill

Built in 1881 to a design by Blackman and Parkes, architects, the rectory was demolished in 1974 having been deemed unsuitable for residential use and too costly to repair. The public outrage caused by its demolition was a major catalyst for the formation of the Ashfield and District Historical Society, whose members, anxious to preserve their suburbs, are currently fighting another round of demolition proposals in the Ashfield Municipality.

Photograph: John Ward; Ashfield and District Historical Society Collection

Strathnairn

Gower Street, Summer Hill

Built in 1887 by architect-builder David Elphinstone, who lived there until his death in 1916. Strathnairn was demolished for home units c.1970. Elphinstone was a member of a large family of architect-builders responsible for many of the terrace houses built in Glebe. Several fine houses designed and built by him in Summer Hill survive.

Photograph: courtesy of Jean Neale; Ashfield and District Historical Society Collection

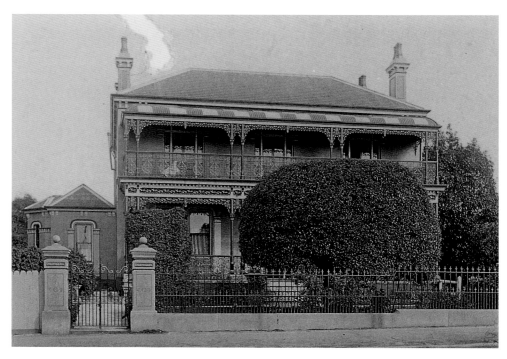

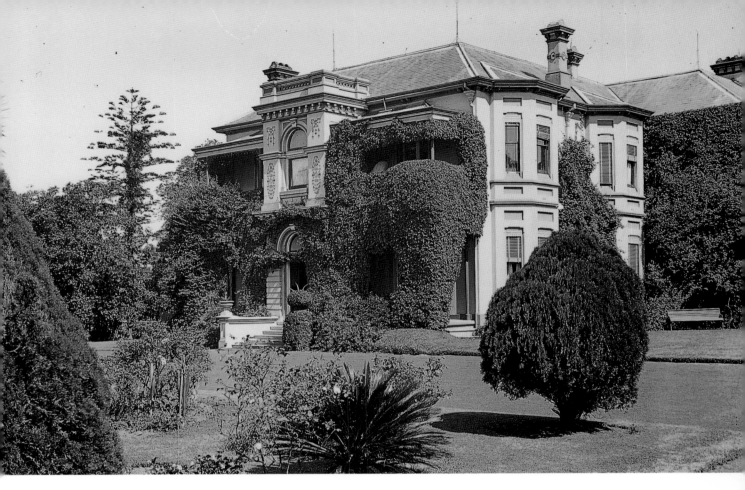

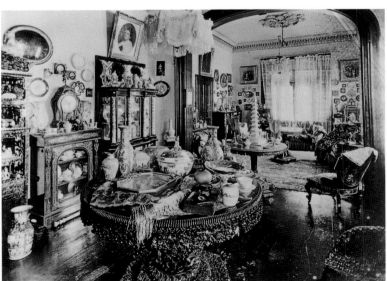

Abergeldie

Old Canterbury Road, Dulwich Hill

Built in the mid-1880s for Hugh Dixson, tobacco merchant and philanthropist, on his thirty-acre (12 ha) estate of which twelve acres were laid out as formal gardens. There was also a large conservatory adjacent to the house where he propagated rare and exotic species. Later knighted, Dixson died in 1926. By 1928 the house, located in the vicinity of 295 Old Canterbury Road, had been demolished for residential subdivision. Dixson's eldest son, (Sir) William, an avid collector of material relating to Australia, inherited his father's benificence, later donating his collection of paintings, books and manuscripts to the Public (now State) Library of New South Wales.

Photograph: (above) Dixson Library, SLNSW; (left) curio room: Private collection, from Marrickville Library Services, Local Studies Collection

Right

Canterbury House
Canterbury

Built c.1850 by Edmund Blacket, architect, for Arthur Jeffreys, whose father-in-law, Robert Campbell had purchased the Canterbury Farm grant in 1803. After Jeffrey's death in 1861 the house was tenanted until purchased in 1876 by John Hay Goodlet, a prosperous businessman well known for his charitable activities. Passing to the Presbyterian Church upon the death of his widow in 1926, the house was sold for residential subdivision and demolished in 1929. Its former site is in Leopold Street, between Leith and Alison Streets, Croydon Park.

Photograph: Royal Australian Historical Society

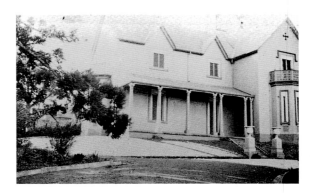

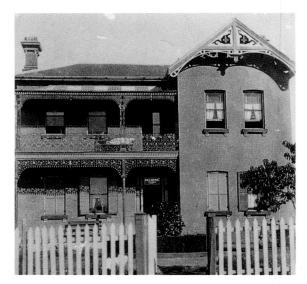

Above

Cottage
513 Chapel Road, Bankstown

A distinctive cottage built 1912-14 by Alfred Gruse, using concrete blocks he had made in a shed at the rear. An early example of the use of concrete in domestic building, and designated to be of heritage significance in the Bankstown Heritage Study undertaken in 1984 by Meredith Walker and Terry Kass. It has since been demolished.

Photograph: Terry Kass; courtesy of Bankstown City Council

Above

Belmore House
Belmore

Built in the1880s for John Fenwick, master mariner and tug boat proprietor, the house remained in family ownership until 1943. Later the clubhouse of Roselands Golf Club, it was demolished in the 1950s for a new clubhouse. Roselands Shopping Centre now occupies the site.

Photograph: courtesy of Hazel Fenwick; Canterbury City Library, Local History Collection

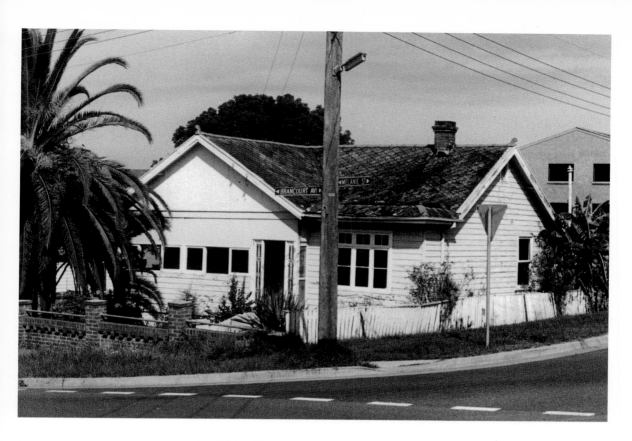

House
92 Brancourt Avenue, Bankstown

This modest weatherboard house with asbestos tile roof, built in 1917 for Janet Lewis, was one of many houses throughout Sydney where, during the Depression, members of the United Workers' Movement took a stand against the police to prevent the eviction of tenants in arrears with their rent. Nadia Wheatley in her chapter in Jill Roe (ed.) *Twentieth Century Sydney* ... (1980) provides a blow-by-blow account of the confrontations in Sydney, but only here at Bankstown and at Newtown did the police shoot at pickets. Locally, the myth persists that a man was killed - but that was at the struggle in Newtown. Of State significance and listed in the Bankstown Heritage Study undertaken by Meredith Walker and Terry Kass in 1984, it has since been demolished.

Photograph: Terry Kass courtesy of Bankstown City Council

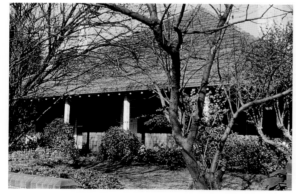

Above

Oakdale
Burwood Road, Belmore

Built c.1912 and used mainly as a doctor's residence and surgery. By the 1920s it was surrounded by substantial Edwardian or Inter-War bungalows, all set amid large informal gardens. Occupied by Dr E. Trenerry from c.1925 until his death in the late 1980s, Oakdale was a familiar landmark, and with its garden, presented the first view of the suburb to people leaving the railway station. Sold to developers, the house was demolished in the late 1980s for shops.

Photograph and information: Lesley Muir

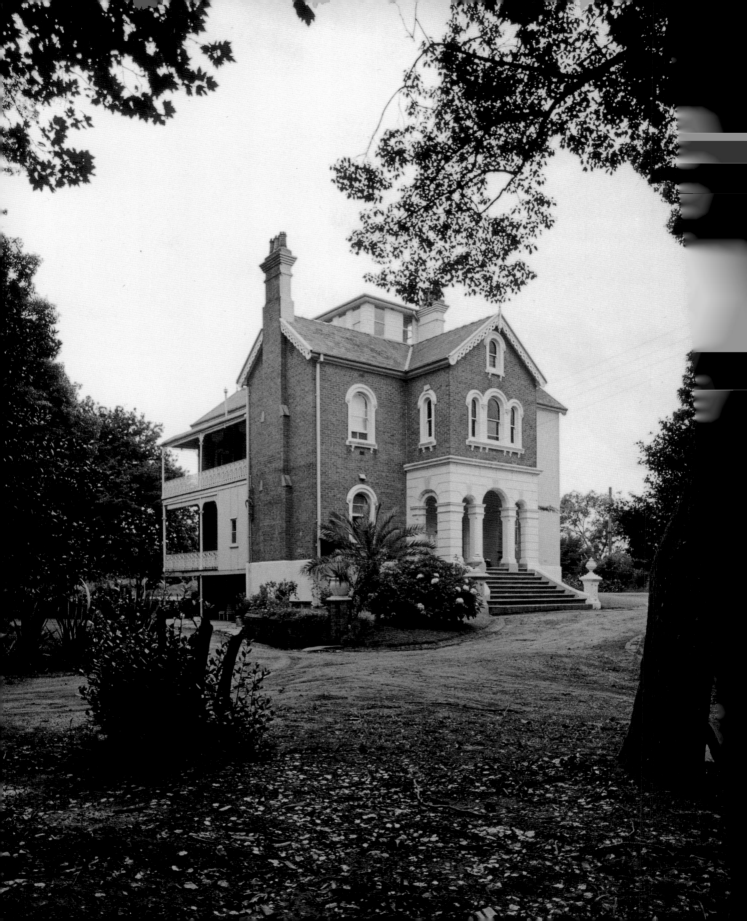

Cambridge House
The Crescent, Fairfield

Built in 1878 by Varney Parkes, architect, for William Stimson, Mayor of Smithfield-Fairfield. Purchased for home unit development in the early 1970s it was used as a community youth centre for two years. The house was damaged by fire, and despite public protest, demolished in 1975. Home units now occupy the site.

Photograph: (opposite) James Whitelock; (below) *Fairfield Champion*

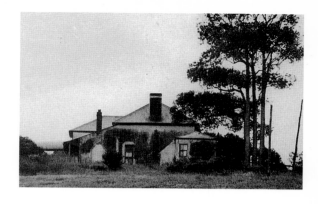

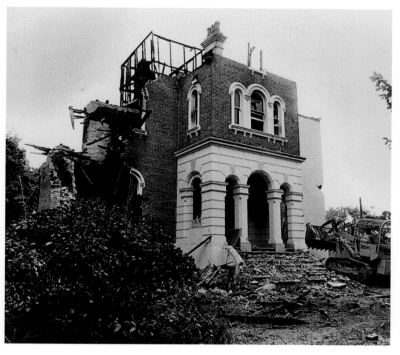

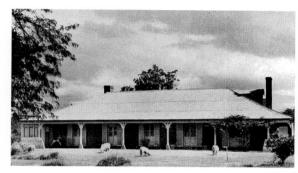

Top

Whinstanes
Wetherill Park

An early farmhouse on Bulls Hill said to have been built for William Lawson. Later owned by Eliza Creasey and her brother John Creasey and his wife, Margaret. Demolished and the hill since excavated for construction of industrial buildings.

Photograph: A. Geikie, *Fairfield Through the Ages*, 1949

Above

Fairfield House
Fairfield

Built c.1870 for Thomas Ware Smart of Darling Point on his Fairfield estate as his country residence. When the railway was extended, the station built near the house took its name, which was later adopted for the suburb. The house was later owned by Mr J. Burleigh, Mayor of Fairfield, and by the Filipich family. Demolished in 1959, a school now occupies the site.

Photograph: A. Geikie, *Fairfield Through the Ages*, 1949

Below

St Luke's Church of England Rectory
Elizabeth Street, Liverpool

Built in 1840 by Henry Robertson, architect, the rectory was demolished for a supermarket in 1965.

Photograph: Barry Wollaston; Historic Houses Trust of NSW

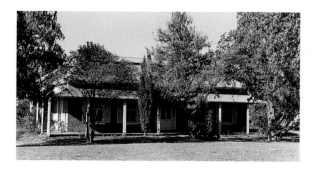

Bernera

Yarrunga Street, Hoxton Park

Built for Alan MacPherson in 1856. In the twentieth century, this vernacular cottage was the home of Olive and Ward Havard, historians and elected officers of the Royal Australian Historical Society. Following its sale, an Interim Conservation Order on the property was gazetted in March 1985. The house was destroyed by fire in April 1986.

Photograph: Robert Irving; National Trust of Australia (NSW)

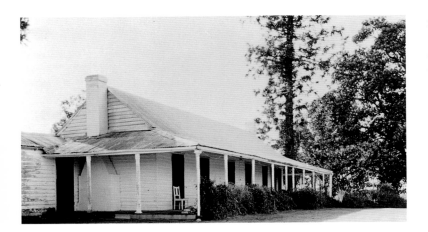

Ingleburn House

Ingleburn

This farmhouse, formerly owned by Mary Kennedy (nee Ruse) who died there in 1874, was purchased and named Ingleburn House in 1881 by Elias P. Laycock, who added the bay-windowed wing. Two years later, the old Macquarie Fields station built nearby in 1869, was renamed Ingleburn. Photographed in 1973, and subsequently demolished.

Photograph: Helen Proudfoot; courtesy of Business Land Group, Campbelltown

Leppington

Denham Court Road, Leppington

Built in the 1820s for William Cordeaux, the property was subsequently farmed by the Payten family until 1873. In ruinous condition, the house was destroyed by fire in the 1960s. A suburb now bears its name.

Photograph: National Trust of Australia (NSW)

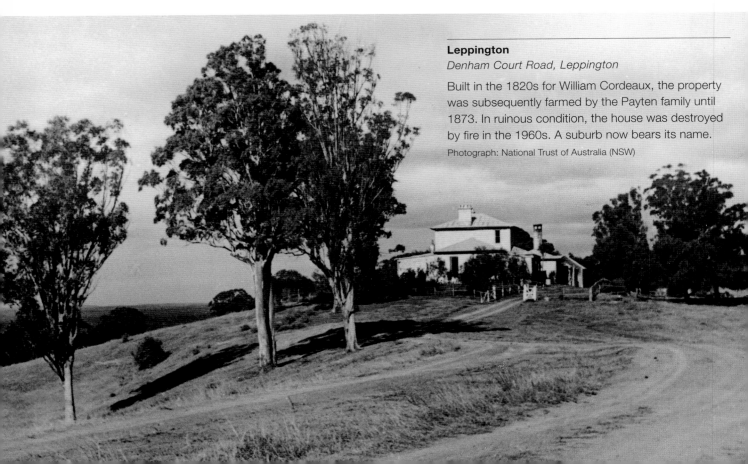

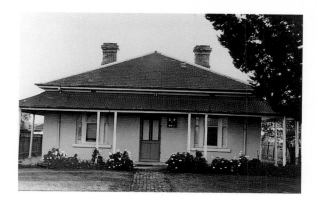

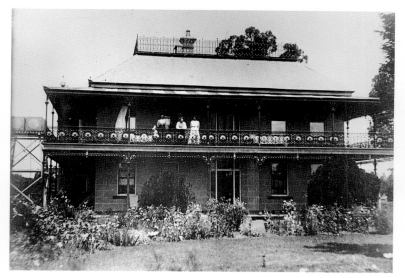

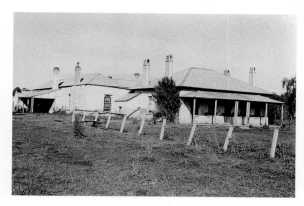

Station Master's House

Patrick Street, Campbelltown

Built in 1892, the house was demolished for a commuter car park in 1981. One of many railway cottages demolished throughout New South Wales.

Photograph: National Trust of Australia (NSW)

Above

Milton Park

Ingleburn

Built in 1882 for David Warby, publican, and dominating the landscape between Macquarie Fields and Ingleburn, the house was privately owned until its purchase in 1952 by the McGarvie Smith Veterinary Research Unit who sold it to Campbelltown City Council in 1973. Isolated and vacant, the house was vandalised and eventually demolished in the early 1990s.

Photograph: Campbelltown City Library, Local Studies Section

Above

Leumeah House

Leumeah

Built c.1820 by John Warby, herdsman and later constable at the Cowpastures, on his grant along Badgally Road, where he lived until his death in 1851. In 1886 local residents successfully lobbied for their new railway platform to be named Leumeah in commemoration of Warby. The house was demolished in 1963.

Photograph: Alex Goodsell; Campbelltown and Airds Historical Society

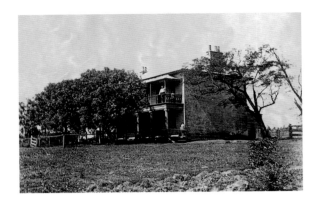

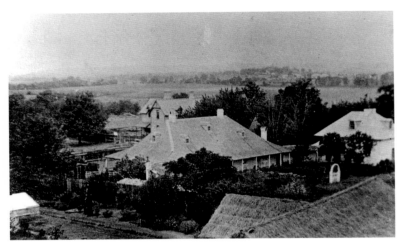

Above

Kirkham
Narellan

Built c.1816 for John Oxley, Surveyor-General of NSW, the house was destroyed by fire and replaced by the stables of James White's new house (later known as Camelot) designed by J. Horbury Hunt in the 1880s.

Photograph: Royal Australian Historical Society

Top left

Bradbury Park
Campbelltown

Named by Governor Macquarie, and built in early 1822 for William Bradbury, it was later acquired by the Chippendall family. The house was demolished in the 1950s; its name survives as one of the new suburbs.

Photograph: Claude Haydon; Campbelltown and Airds Historical Society.

Top right

Glen Lorne
Campbelltown

An early colonial cottage purchased in 1878 by George A. Mansfield, architect, who added the wings and named the house in honour of his wife. Mansfield died there in 1908. The house was destroyed by fire in 1981.

Photograph: National Trust of Australia (NSW)

Below left

Terrace
Hume Highway, Narellan

This early colonial terrace, variously known as Narellan House and as Post Office Terrace, was the residence of Harold Rudd in 1903 when he was appointed postmaster at Narellan. Succeeded in 1950 by his daughter Enid, and occupied by the Misses Rudd until the 1970s, this familiar landmark on the Hume Highway was demolished for shops in 1978.

Photograph: National Trust of Australia (NSW)

WEST

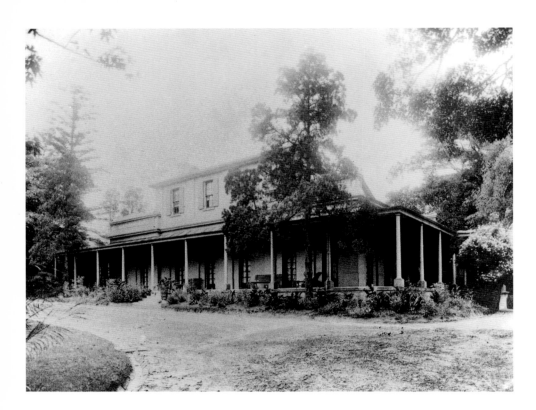

Above

Hereford House

Glebe Point Road, Glebe

Built in 1829 by Edward Hallen, architect, for George
Williams, and with additions by Edmund Blacket,
architect for Thomas Woolley in the late 1840s, the
house was purchased by the state government in
1910 for use as a teachers' training college. Its site is
now a public park.

Photograph: GPO 1, Mitchell Library, SLNSW

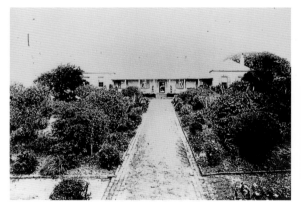

Right

Annandale

Annandale

Built c.1820, possibly incorporating an earlier house,
for Colonel George Johnston on his grant of 1798.
Located on the southern side of Parramatta Road,
between Macaulay and Albany Roads, the house
remained in the ownership of the Johnston family until
its demolition for residential subdivision in 1905.

Photograph: (above right) Josephine E. Foster; GPO 1, Mitchell
Library, SLNSW; (right) Josephine E. Foster; Royal Australian
Historical Society

Right

Elswick

Leichhardt

Built in 1832 for James Foster, with later additions for James Norton, solicitor, owner from 1834 until his death in 1862. The house, later acquired by a Catholic order, becoming St Martha's Industrial Home for Girls and extensively altered 1901-34, was demolished for a new building in 1939.

Photograph: Royal Australian Historical Society

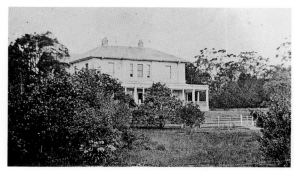

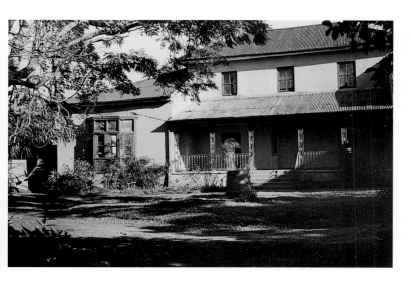

Left

Birch Grove

Louisa Road, Birchgrove

Built c.1812 for John Birch, Paymaster of the 73rd Regiment, with additions for a subsequent owner, the house was demolished for home units in 1967.

Photograph: James Whitelock

Bottom left

Waterview

Balmain

Built by 1836, the house became the 'centre of literary Sydney' from 1856 to 1873 when occupied by Nicol Drysdale Stenhouse, lawyer and literary patron. An account of this period of the house's history is provided by Ann-Mari Jordens in *The Stenhouse Circle ...* (1979). Waterview was sold by Stenhouse's widow Margaretta in 1894. Located near the corner of Caroline Street and Broadstairs (now Colgate Avenue) and extant in 1905, the house had been demolished for residential subdivision by 1921.

Photograph: S.N. Hogg; Mitchell Library, SLNSW

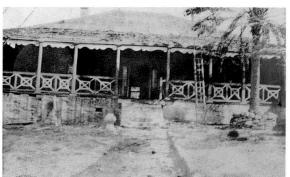

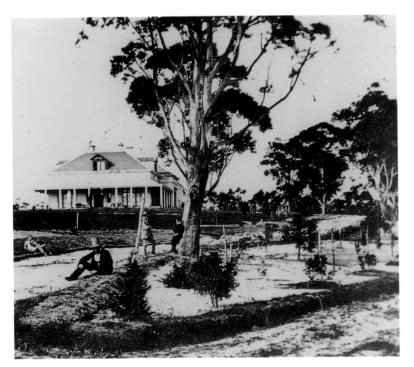

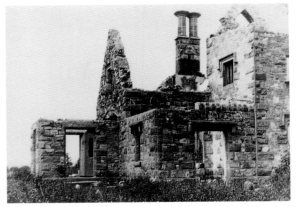

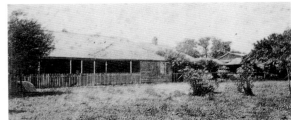

Top right

Barnstaple Manor
Rodd Point, Five Dock

Built c.1845 possibly by John Frederick Hilly,
architect, for Brent Clements Rodd. Located in the
vicinity of present Brisbane Avenue, the house in
dereliction, was demolished for residential subdivision
in 1927.

Photograph: National Library of Australia

Top Left

Drummoyne House
Wrights Road, Drummoyne

Built c.1853 for William Wright, merchant, with
additions clearly visible in this 1850s photograph
taken by Professor John Smith, University of Sydney.
Wright lived at Drummoyne House until his death in
c.1890. Later the home of the McDonagh sisters and
used in their films, the house was demolished for
home units c.1970.

Photograph: Prof. John Smith, GPO 1, Mitchell Library, SLNSW

Above

Dobroyde House
Dobroyd Point

Dobroyde House stood just north of Parramatta
Road, almost opposite present Ashfield Park, on land
granted in 1803 to Nicholas Bayly, and sold to
Simeon Lord in 1805. Named Dobroyde by Lord, the
estate, which covered all of present Haberfield and
Dobroyd Point, was transferred to his daughter Sarah
upon her marriage to Dr David Ramsay in 1825. The
house, described in 1816 as an 'elegant villa',
remained in the Ramsay family until its purchase by
Richard Stanton, developer of the Haberfield estate,
who demolished it c.1905 to clear the site for his new
home, The Bunyas. At the time of its demolition,
Dobroyde House was the oldest building in Ashfield
municipality.

Photograph: Ashfield and District Historical Society Collection

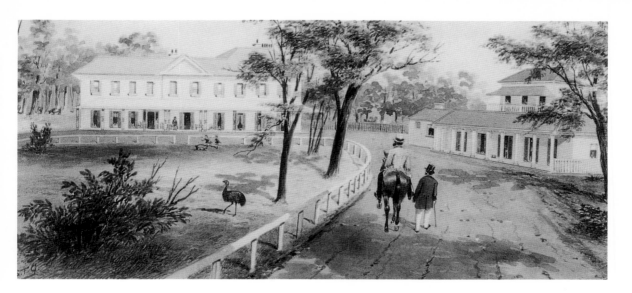

Above

Ashfield Park House

Ashfield

The first Ashfield Park house (right) was built c.1815 for Robert Campbell senior. The second (left) begun in 1832 by Joseph Underwood as its stables was completed as a house by his widow, Elizabeth. Purchasing the estate in 1861, Samuel Smyth demolished the original house and enlarged the second. The latter was demolished in 1909 or 1910.

Illustration: S.T. Gill, *Ashfield Park*, watercolour. Private collection

Below

Ellalong

Holden Street, Ashfield

Built c.1865 for George K. Holden, solicitor, and one of the substantial villas erected after the coming of the railway in 1855. Demolished c.1920.

Photograph: courtesy of Penelope Pike; Ashfield and District Historical Society Collection

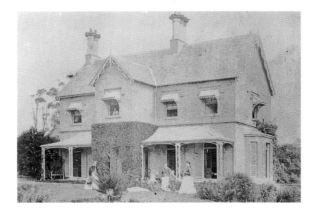

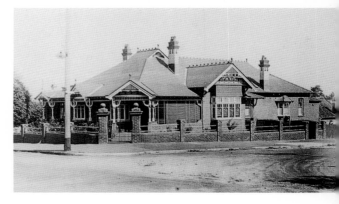

Above

Clavering

Orpington Street, Ashfield

A fine example of a Queen Anne house, and one of the largest houses of this style to be built in the Ashfield municipality, Clavering was built in the early 1900s for William Rogers, owner of a shop and bakery in nearby Loftus Street since the late 1880s. It was demolished for home units c.1970.

Photograph: courtesy of Bill Dunstan; Ashfield and District Historical Society Collection

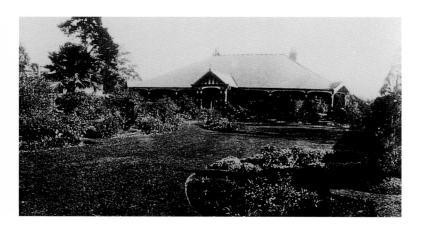

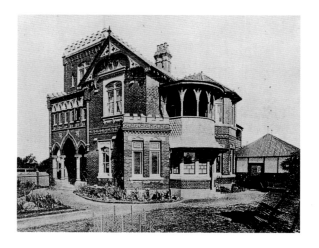

Burwood Villa

Park Road, Burwood

Built c.1814 for Alexander Riley and remodelled as a Queen Anne bungalow c.1905, possibly by Harry Kent, architect, the house was demolished for a residential subdivision in 1937.

Illustration: *Illustrated Sydney News* 1854; photograph (below left) Burwood Historical Society

Below

Evandale

Queen Street, Burwood

Built in 1868 for Captain Henry T. Fox, master mariner and insurance agent, who resided there until his death in 1891. Demolished in 1927, its site is now Blair Park.

Photograph: SPF, Mitchell Library, SLNSW

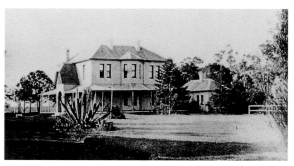

Left

Tudor House

College Street, Drummoyne

Built c.1897 for Sir Thomas Henley, politician and Mayor of Drummoyne, and his residence until his death in 1935, the house was demolished for home units in 1970.

Photograph: *Sunday Times*, 1907

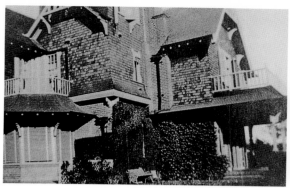

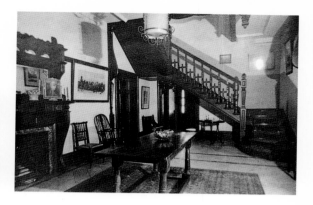

Above left and above

Bickley
Albyn and Kingsland Roads, Strathfield

Built in 1894 for Mrs Edward Lloyd Jones to a design by her nephew, George Sydney Jones, architect, this fine example of his work was demolished in 1956 and five houses built on its site. Treaghre and Luleo, two other houses in Albyn Street by Jones survive, the latter extensively altered.

Photographs and information courtesy Dr John Phillips

Left

Homebush
Homebush

Built by 1827 for D'Arcy Wentworth, Superintendent of Police; the house was leased in the early 1840s by Charles Meredith and his wife Louisa Anne, whose *Notes and Sketches of New South Wales* (1844) provides an account of their occupancy. Ruinous by the turn of the century, the house was demolished c.1915 for the government abattoirs, now part of the Olympic Games site.

Photograph: Royal Australian Historical Society

Below right

Strathfield House
Strathfield

Built as Strathfieldsaye in 1868 for Walter Renny, painter and decorator and Mayor of Sydney 1869-70, the name was shortened to Strathfield by its third owner in the 1870s. Purchased in 1881 by John Hardy of Hardy Brothers, silversmiths and jewellers, in 1885 the house name was adopted for the district then known as Redmyre. The tower and upper verandahs were added c.1907 following its purchase by Joseph Vickery, who subdivided parts of the estate in 1930 and 1937. Located near the western end of Strathfield Avenue, the house was tenanted from 1940 until 1957 when it was demolished for residential subdivision.

Photograph: Mitchell Library, SLNSW

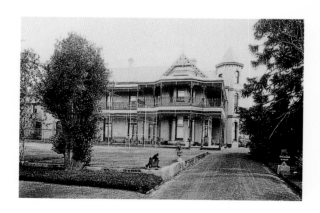

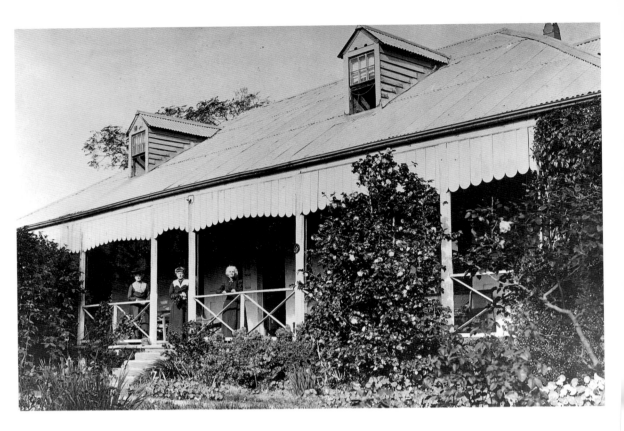

Rhodes
Rhodes

Built in 1823 for Thomas Walker, the house was
tenanted 1832-1870 when he and his family resided
in Tasmania. His widow Anna (nee Blaxland) and their
three unmarried daughters returned to Rhodes, living
there for the remainder of their lives. The house,
overlooking the Parramatta River near the northern
end of Blaxland Road, was demolished for a factory
c.1918.

Photograph: Royal Australian Historical Society

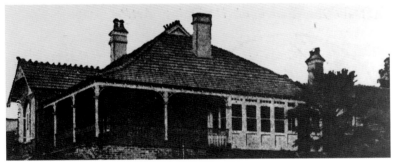

Above

Oaklands
104 Adderley Street, Auburn

The home of John Thomas (Jack) Lang, Premier of
New South Wales and one of the most controversial
figures in the political history of New South Wales. An
Auburn real estate agent at the turn of the century,
Lang purchased Oaklands, with its commanding
views to the Parramatta River, from a member of the
Mashman family c.1910 and was living there when
premier in the 1920s. He died at his later Auburn
residence in 1975. This fuzzy picture from an unidenti-
fied newspaper is the only photograph of the house
found to date. The house was demolished for a factory.

Photograph: Auburn District Historical Society

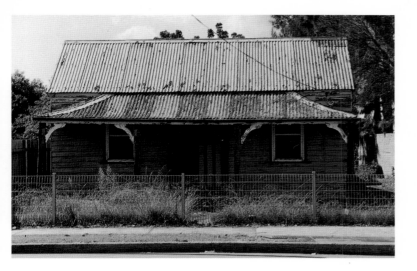

Below and bottom right

Locksley Hall
Merrylands

Built as Sutherland House in the late 1870s for A.S. Lowe and renamed following its sale in the 1890s to Mrs William Harkness. Located in the vicinity of Locksley Avenue, the house was demolished in 1937 for residential subdivision.

Photographs and information: W.A.J. Maston

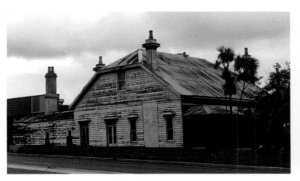

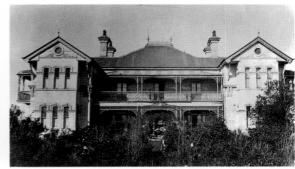

Top

Cottage
69 John Street, Lidcombe

Built in 1876 by Aaron Burton, a gravedigger at nearby Rookwood Cemetery and later superintendent of its Church of England section, the cottage, with its 1894 additions, remained structurally unaltered and occupied by his last surviving child in 1988. Dismantled in 1994 and still awaiting re-erection on another site, its fabric continues to deteriorate in the local council depot.

Photograph: Liz Roveen

Above

Cottage
Woodville Road and William Street, Granville

Built in the 1880s and owned for part of the twentieth century by the Downey family, this jerkin-head roofed cottage was a familiar landmark in the suburb. It was destroyed by fire in the early 1990s.

Photograph and information: Terry Kass

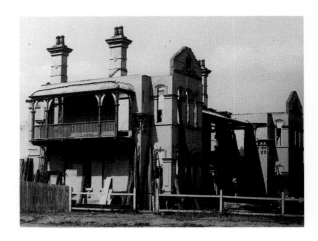

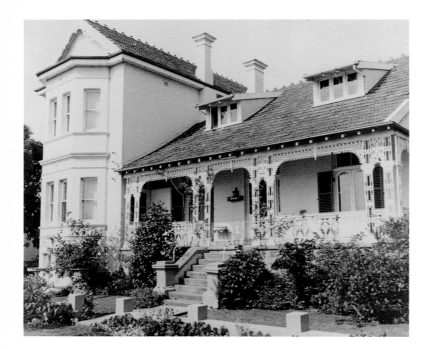

Parramatta

Parramatta survived with a substantial number of its colonial residences intact until the mid-twentieth century, the new buildings of the Victorian and Edwardian eras having fitted in comfortably between the older houses. It was a country town where residences were intermixed with shops and pubs, where industrial activities rubbed shoulders with leisure spots.

All this changed with the gazetting of the County of Cumberland Planning Scheme of 1951 and its successor, the Sydney Region Outline Plan in 1968. Following council amalgamations in 1947, a new and larger Parramatta City adopted its designated role as a major urban centre. Though the Cumberland Scheme recognised in principle that heritage was a part of community identity, in practice heritage was narrowly defined to a few icon sites.

There was still enough space in Parramatta in the 1950s for new development to consolidate behind the older facades. Then came the greedy 1960s and within a decade the colonial town had been razed to the ground – replaced by undistinguished glass and concrete corporate towers and government offices. The streets lost their distinctiveness. No more a country town where work and home merged, Parramatta's identity drained away into an anonymous CBD.

Carol Liston, University of Western Sydney (Nepean), 1999

Left

Ranleigh
The Park, Parramatta

Built in 1863 for Samuel Burge, Mayor of Parramatta; the three-storey wing was added in 1896 for the Fullager family, owners from 1895 to 1963 and who leased the house to the King's School 1908-1910. It was later a popular venue for wedding receptions. The Parramatta Trust and other community groups lobbied to save Ranleigh when an Interim Conservation Order on the property was not renewed. Demolished c.1986 the site remains vacant.

Photograph: courtesy of Shylie Brown

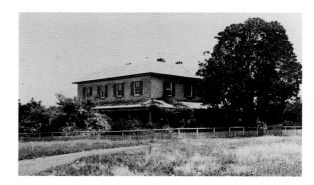

Above

Athole
Thomas Street, Parramatta

Built as Newlands in 1835 for the Marsden family, but never occupied by them, the house was purchased and renamed Athole in 1856 by Neil Stewart who lived there for more than fifty years. Demolished by the Department of Education c.1932 for a secondary school (now Macarthur Girls High School).

Photograph: Royal Australian Historical Society

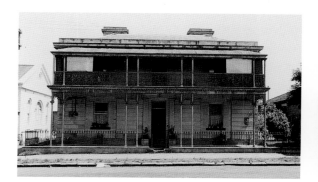

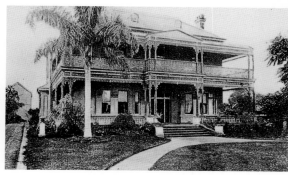

Above left

Tara

George Street and Barrack Lane, Parramatta

A fine example of an early town house, built in 1841 by James Houison, architect, for Nathaniel and Susannah Payten who died there in 1864 and 1877 respectively. Purchased in 1877 by Dr Waugh, his daughters established the school, Tara, there in 1912 and which continued on the site until 1959. Illustrated here with its verandah additions, the house was demolished for a factory in 1963.

Photograph: Barry Wollaston; Historic Houses Trust of NSW

Above

Hiawatha

George Street, Parramatta

Built in 1883 for J. W. Withers, Mayor of Parramatta, and a good example of a Victorian town house, Hiawatha was a popular venue for wedding receptions in the mid-twentieth century. Demolished in the 1960s for a bowling alley, since demolished for a commercial building.

Photograph and information: from Shylie Brown

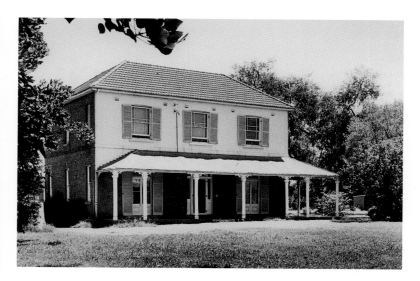

Above

All Saints' Church of England Rectory

Elizabeth Street, Parramatta

Built in 1874, its iron roof later replaced by tiles, it was demolished, despite local protest, for a new rectory in 1975.

Photograph: Rob Hillier; Mitchell Library, SLNSW

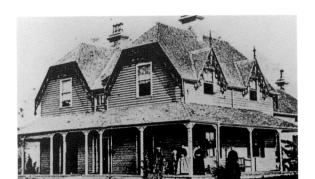

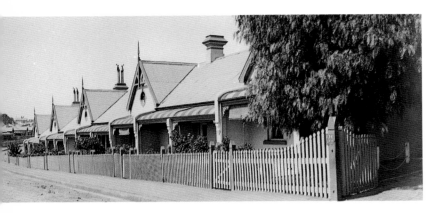

Above

Cottages
Valentine Street, Parramatta

These cottages, built in 1890, signalled the government's new approach to the provision of accommodation for aged destitute married couples, who before this, would have been separated and placed in male and female asylums, usually without further contact. Demolished for commercial development.

Photograph: GPO 1, Mitchell Library, SLNSW

Right

Nairn Cottage
Hawkesbury Road, Westmead

Built c.1862 by James Houison, architect, as his country residence, the house was purchased in 1936 by the Church of England and the groundfloor used as a church. Demolished in the early 1950s, sandstone blocks from the house were used for the walls of St Barnabas's Church which now occupies the site.

Photograph: Royal Australian Historical Society

Left

Hanleyville
Macquarie Street, Parramatta

Built in 1868 on the site of the old Shelley family cottage for Reverend Ralph Mansfield and his second wife Lucy (nee Shelley), its design probably derived from a pattern book and refined by his son, George Mansfield, architect. Later the home of the Reverend Mr Inglis, and after his death in 1893, a school opened by his daughters named by them Hanleyville which continued on the site until 1924. Located between Church and Marsden Streets, the house was demolished for commercial buildings.

Photograph: Henry Beaufoy Merlin; courtesy of Nora Pickering

Below

Edgeworth
Macquarie Street, Parramatta

Built in the late 1840s for James Byrnes, a local businessman who later served as the local member for, and second mayor of, Parramatta. Demolished c.1915 and new houses erected on the site.

Photograph: courtesy of Carol Liston

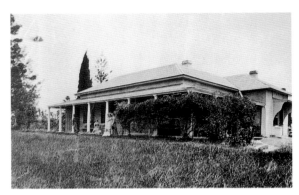

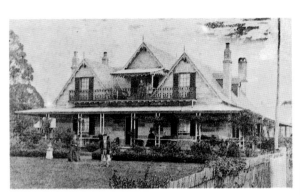

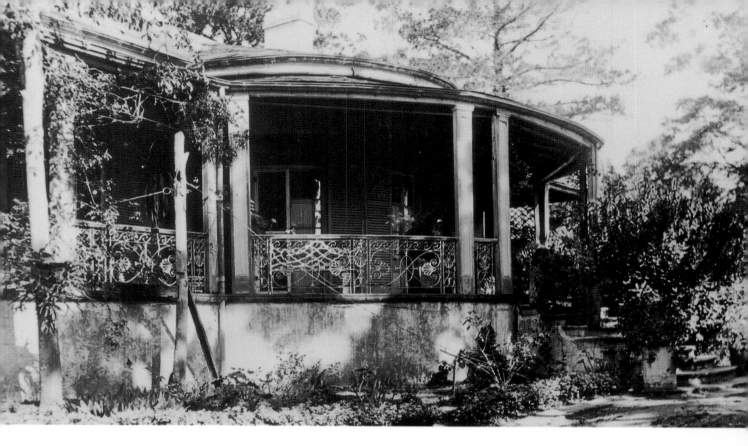

Above

Grey Stanes

Prospect

Built in the late 1830s by William Lawson for his son Nelson Simmons Lawson, the house was severely damaged during World War II by servicemen camped in Prospect Hill and demolished.

Photograph: Harold Cazneaux; Mitchell Library, SLNSW

Left

Cottage

Gipps Road, Greystanes

Built in the late nineteenth century for John Booth, farmer, and alderman of Prospect and Sherwood Council 1880-1887, and his wife and seven children. Suffering injuries during the 1890s depression, Booth was unable to work and was forced to rent the farm, dying in 1900. Booth's finely detailed cottage is representative of the many cottages built on large blocks in the area when it was semi-rural. As suburbia encroaches cottages such as these are disappearing from the landscape.

Photograph: W.A.J. Maston

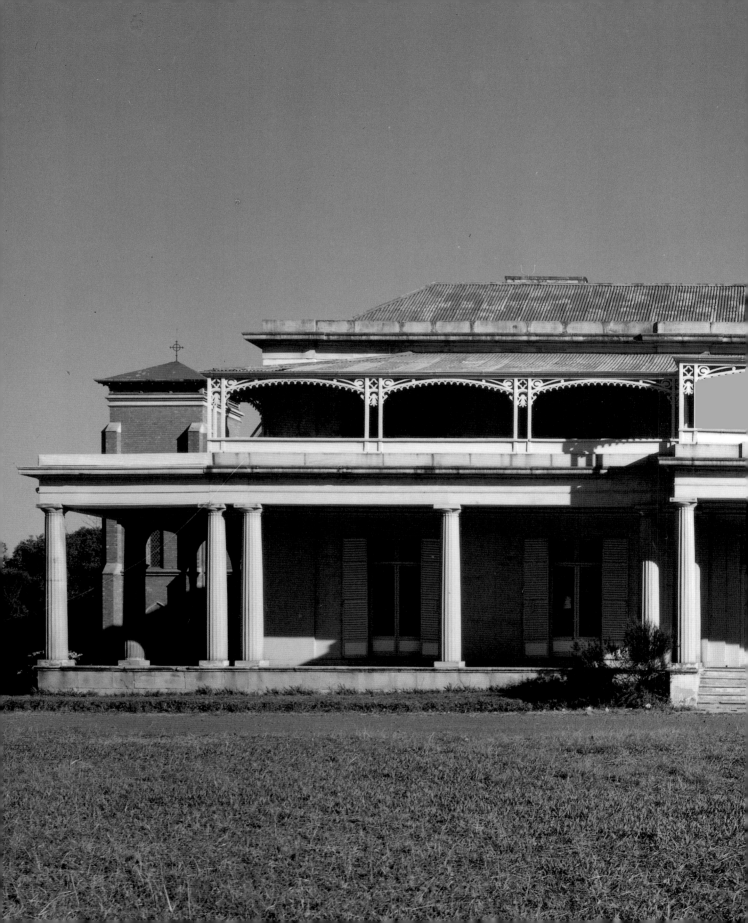

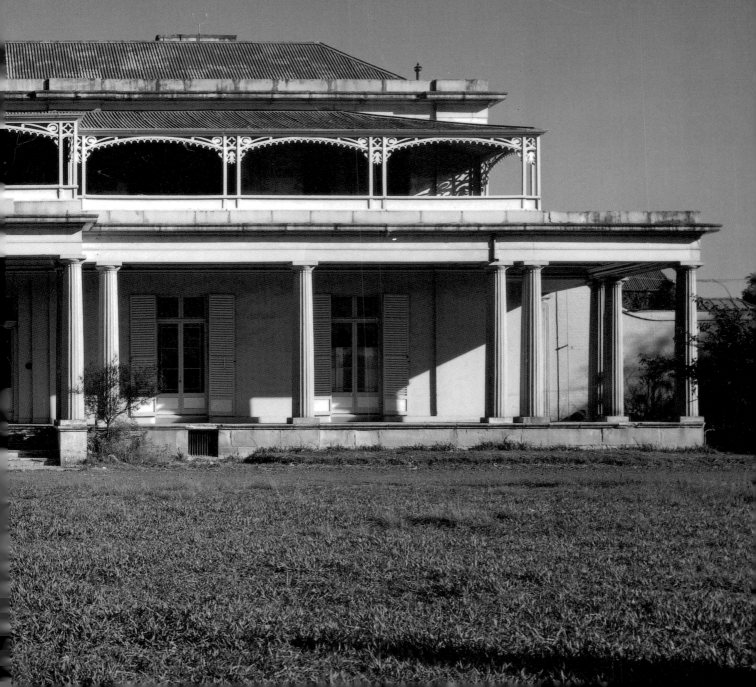

Subiaco (Vineyard)
Rydalmere

Built in 1836 by John Verge, architect, for Hannibal Hawkins Macarthur, whose financial decline in the 1840s depression, forced its sale to Thomas Icely c.1845. From 1849, the house, renamed Subiaco, was owned by the Benedictine community until put up for sale in 1960. Purchased by Rheem Australia Pty Ltd, the National Trust waged a major campaign for its preservation. The house was demolished for a car park in 1961.

Photograph: Max Dupain; Max Dupain & Associates

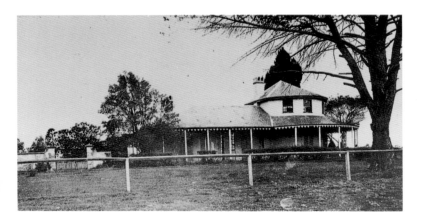

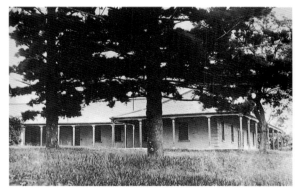

Top left and above

Bungarribee
Eastern Creek

Built in 1827 for Colonel John Campbell who died later that year, the house was possibly completed after its purchase by Thomas Icely in 1828. In 1954, when in ruinous condition and owned by the Overseas Telecommunications Commission, the house was offered to the National Trust whose members seriously considered its restoration, however, the terms of the lease precluded its demolition should the site be required for the commission's expansion. Located in Doonside Road, the house was demolished in 1957.

Photograph: (top left) Royal Australian Historical Society; (above) Mitchell Library, SLNSW

Top right

Government Stock Farm
Rooty Hill

Built in 1815 for the superintendent; two rooms added by Governor Macquarie 'for his convenience'. Ruinous in the 1960s and demolished.

Photograph: Royal Australian Historical Society

Above

Veteran Hall
Prospect

Built c.1820 for William Lawson, and later purchased by Metropolitan Water Sewerage and Drainage Board for Prospect Reservoir. Demolished in 1929.

Photograph: SPF, Mitchell Library, SLNSW

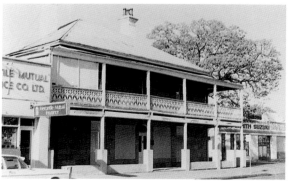

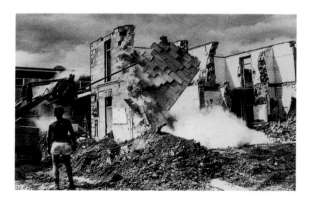

Above

Regentville
Regentville

Built 1823-25 possibly by Francis Greenway, architect, for Sir John Jamison, the house was deliberately burnt in 1869.

Illustration: Conrad Martens, Regentville, Oct 17/35. Pencil sketch. Mitchell Library, SLNSW

Left and below left

Ormonde
High Street, Penrith

Built in the 1880s for William Dent from stone salvaged from the ruins of Regentville. Demolished for a shopping complex in 1979.

Photograph: (left) Private collection; (below left) John Fairfax Ltd

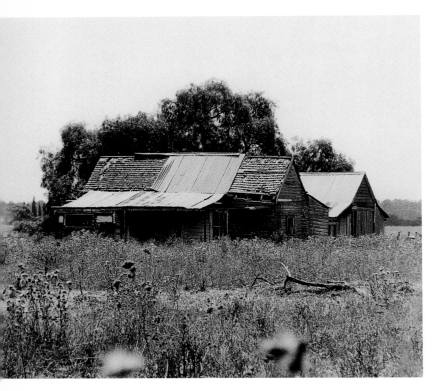

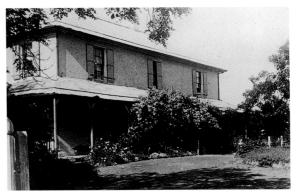

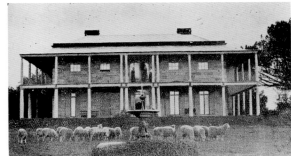

Above

Cottage

Castlereagh Road, Upper Castlereagh

An early slab cottage with outbuildings known as Parker's house and butchery, and one of a number of early buildings demolished for the construction of the Penrith Lakes Scheme. Of the 100 buildings featured in Daphne Kingston's *Early Slab Buildings of the Sydney Region*, 37 have been demolished since its publication in 1985.

Photograph and information: Daphne Kingston

Top right

St Thomas Church of England Rectory

Mulgoa

Built c.1838, it was demolished for a new rectory c.1960.

Photograph: Royal Australian Historical Society

Centre right

Winbourne

Mulgoa

Built in the 1820s for George Cox, with the addition of a second storey in 1840, the house was destroyed by fire in 1920.

Photograph: Royal Australian Historical Society

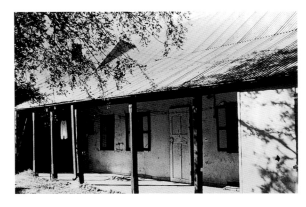

Above

Cranebrook

McCarthys Lane, Cranebrook

Built for James McCarthy on his grant of 1807, an exceptional complex of vernacular structures around a large courtyard. Demolished in 1974 by Blue Metal Industries which had acquired the site for quarrying purposes. An early centre of Roman Catholicism in the colony.

Photograph: Private collection

NORTH AND NORTH-WEST

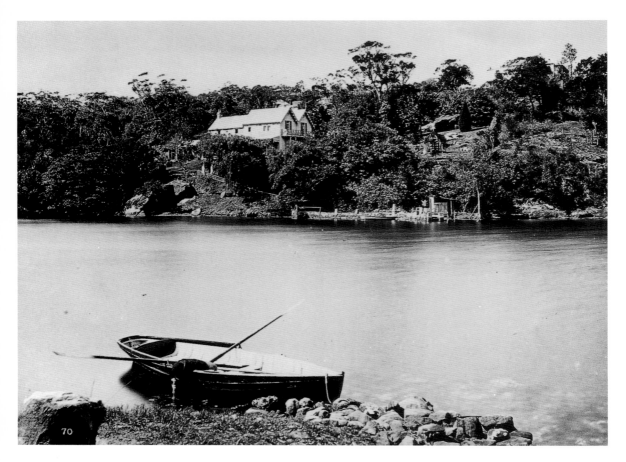

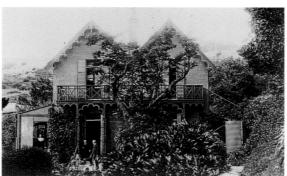

Ivy Cliff

Berrys Bay

Built for Charles H. Woolcott, Town Clerk of Sydney, the house was purchased by North Sydney Municipal Council and demolished for a public park in the 1930s.

Photograph: (above) Royal Australian Historical Society; (left) SPF (BM), Mitchell Library, SLNSW

Bellvue

Blues Point Road, Blues Point

Built 1871-73 by Edmund Blacket, architect, on land owned by William Woolcott, this Gothic cottage, purchased in 1873 by Moses Bell and named Bellvue, was demolished for the garages of Blues Point Tower unit block 1958-59.

Photograph: Ruth Wood Collection; Stanton Library, North Sydney

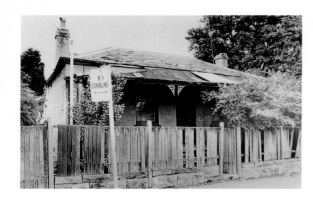

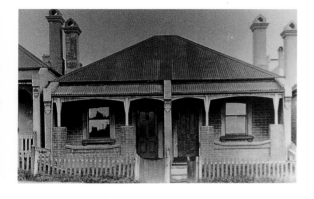

Top

Cottage
70 Union Street, McMahons Point

A mid-nineteenth century verandahed cottage, demolished, despite local protest, by Sydney Church of England Grammar School (Shore), for additional playground space in 1975, a fate shared in the early 1980s by a similar cottage at 76 Union Street.

Photograph: National Trust of Australia (NSW)

Above

Houses
Broughton Street, North Sydney

These semi-detached houses, built c.1905, are typical of the modest dwellings in Broughton Street demolished for Sydney Harbour Bridge c.1927.

Photograph: GPO 1, Mitchell Library, SLNSW

Below

Grantham
Grantham Street, North Sydney

Built by James Milson for his daughter and occupied for some time before his death in 1856 by Rear Admiral Phillip Parker King, son of Governor King. Demolished, as was all of Grantham Street, for Sydney Harbour Bridge c.1925.

Photograph: Royal Australian Historical Society

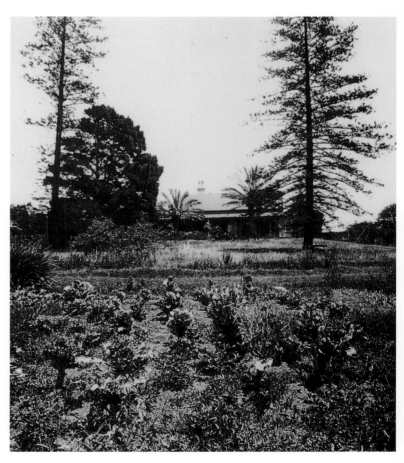

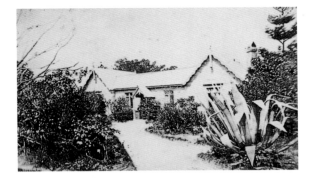

Left

Rockleigh Grange
North Sydney

Built in 1843 to a pattern-book design for the artist Conrad Martens whose numerous paintings and sketches of the colony's houses are often their only surviving visual record. Sold following Martens's death in 1878, the house, located near present Edward Street, was demolished for a new one of the same name after 1890 which, in turn, was demolished in the late 1970s by the Catholic University.

Photograph: Macarthur Papers, Mitchell Library, SLNSW

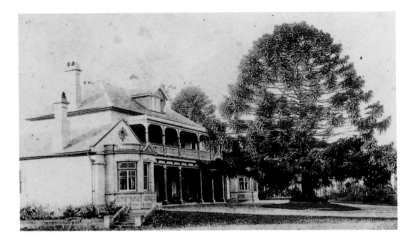

Left

Crows Nest House
Pacific Highway, Crows Nest

Built in 1850 for Alexander Berry who lived there until his death in 1873. Later owned by Sir John Hay, the house was demolished for North Sydney Primary School in 1932. Its gateposts remain.

Photograph: SPF, Mitchell Library, SLNSW

Right

Crows Nest Cottage
Crows Nest

Built c.1820 for Edward Wollstonecraft, its site in Shirley Road, inherited by Sir John Hay, was donated by the family for a Presbyterian church in 1904.

Photograph: Royal Australian Historical Society

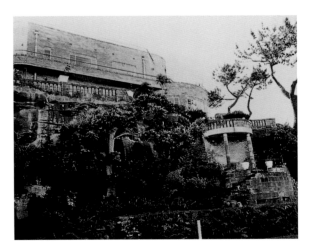

Left

Baden House
5-7 Baden Street, Neutral Bay

Built in 1937 on the edge of Sydney Harbour for Sir Ernest and Lady White to a design, said to be of exceptional quality, of Kenneth McConnel of Fowell and McConnel, architects. The house requiring substantial structural repairs, was sold in 1984 and demolished for luxury town houses.

Photograph: Brendan Lennard; National Trust of Australia (NSW)

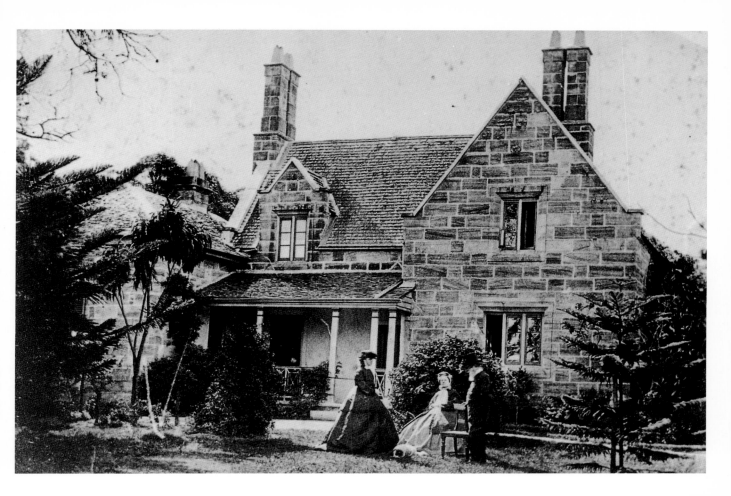

Above

St Thomas' Church of England Rectory
North Sydney

Built in 1846, adjacent to the church, it was demolished and replaced by a new rectory c.1900.

Photograph: SPF (BM), Mitchell Library, SLNSW

Right

House
23 Bay Road, Waverton

Built in 1923 for William Richards, this California bungalow with its fashionable interiors, was demolished for home units c.1970.

Photographs: Richards Collection, Macleay Museum

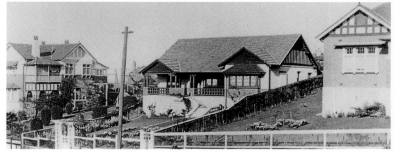

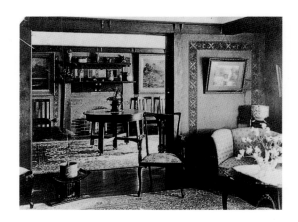

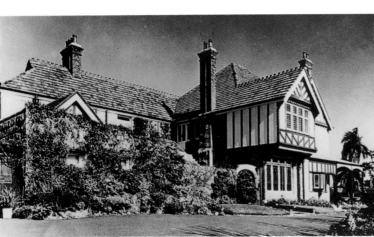

Clee Villa

Lower Wycombe Road, Neutral Bay

An early cottage on the lower North Shore, built in 1832 for Thomas Lindley, and occupied in the late nineteenth century by the Mann family, it was demolished for flats in 1934.

Photograph: Stanton Library, North Sydney

Below left

Penshurst

Penshurst Avenue, Neutral Bay

Built in 1885 by Walter Liberty Vernon, later Government Architect, for himself, the house was demolished for home units in 1968.

Photograph: National Trust of Australia (NSW)

Bottom left and below

Rahnie

Barry Street, Neutral Bay

Built in the early 1900s for Mary and Thomas Ilbery and set in substantial grounds with its own croquet lawn, the house remained in family ownership until the 1960s when it was sold and demolished soon after for home units. Ilbery Park named for the family is adjacent to the site.

Photographs: Stanton Library, North Sydney

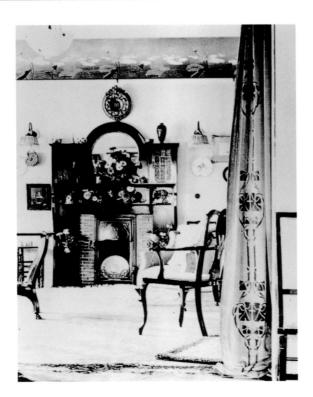

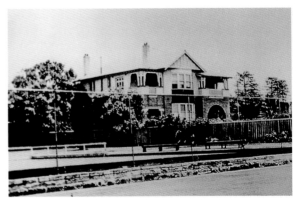

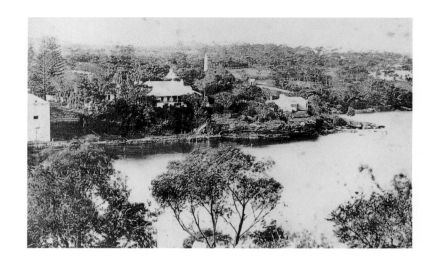

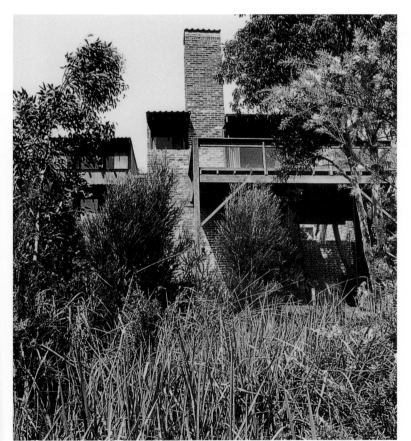

Above

Craignathan

Hayes Street, Neutral Bay

Built in 1831 for James McLaren, later occupants included Benjamin Boyd, Captain E. Moriarty, Lady Mitchell, widow of Sir Thomas Mitchell and the Mann family. The house with a second storey from 1910 was demolished by the Commonwealth Department of Works for naval facilities in 1968.

Photograph: SPF (BM), Mitchell Library, SLNSW

Left

House

Carrington Avenue, Mosman

Built 1965-67 for Billie and Hal Myers, to a design of Ken Woolley, architect. A finalist for the Wilkinson Award in 1967, and an outstanding example of a split-level clinker brick house of this period, it was sold in 1984 and demolished for a new house in 1988.

Photograph: Harry Sowden; Ancher Mortlock & Woolley

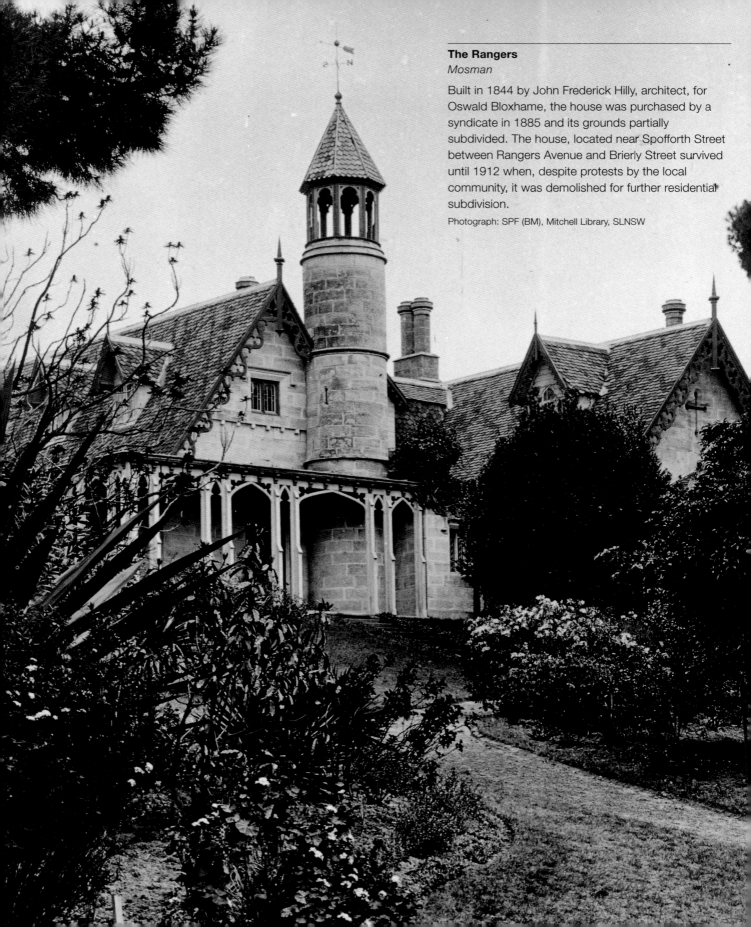

The Rangers

Mosman

Built in 1844 by John Frederick Hilly, architect, for Oswald Bloxhame, the house was purchased by a syndicate in 1885 and its grounds partially subdivided. The house, located near Spofforth Street between Rangers Avenue and Brierly Street survived until 1912 when, despite protests by the local community, it was demolished for further residential subdivision.

Photograph: SPF (BM), Mitchell Library, SLNSW

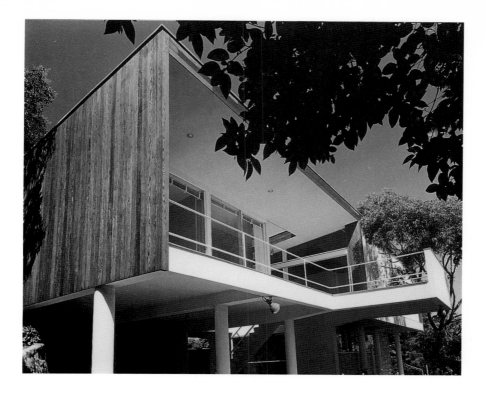

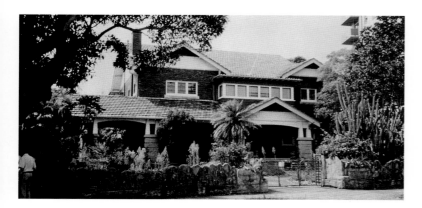

House

McLeod Street, Mosman Bay

Built 1951-52 for the Lowe family to a design of Harry Seidler, architect, the house was demolished in the mid 1990s for town houses.

Photograph: Max Dupain; Max Dupain & Associates

Left

The Nest

Mosman

Built in 1832 for Archibald Mosman, the earliest substantial house built in the area, its later occupants included Richard Harnett and Dr and Mrs Charles Badham. Demolished for residential subdivision and the formation of Badham Avenue in 1921.

Photograph: SPF (BM), Mitchell Library, SLNSW

Left

The Cedars

69 Bradleys Head Road, Mosman

Built in the early 1920s for A. E. Palmer, a rare two-storeyed California bungalow, its interiors included early examples of built-in furniture of Queensland maple of the highest craftsmanship. Damaged by fire in February 1993, the house was demolished in 1994. Home units now occupy the site.

Photograph: Sheridan Burke

Eden George's House
The Esplanade, Manly

Built in 1904 for Eden George, well-known photographer, its elaborately decorated interiors included a large ballroom. Later Joffre Flats, the house was demolished for home units in 1958.

Photograph: *Sunday Times*, 1907

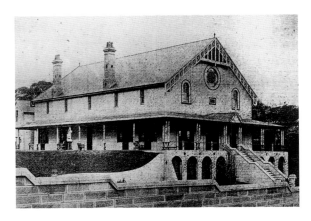

Right

Fairlight House
Fairlight

Built in 1854 for Henry Gilbert Smith, its tower and porch were added in the early 1880s by John Woods, building contractor and Mayor of Sydney. The house was demolished for flats in 1939.

Photograph: Macleay Museum

Below

Marinella
Manly

Built in 1881 for William Bede Dalley, Attorney-General of NSW, the mansion (known as Dalley's Castle) overlooking Manly Cove, was demolished for flats in 1939.

Photograph: Royal Australian Historical Society

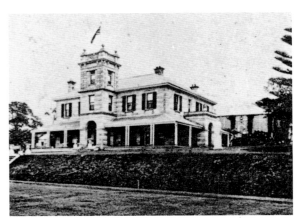

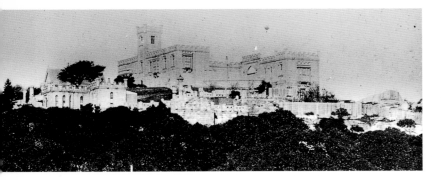

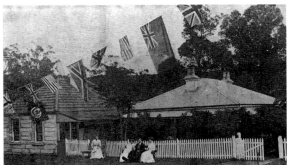

Above

Brookvale House
Brookvale

Built in 1883 for Sydney Alexander Malcolm when the area was known as Greenvale, the house was occupied by his daughter Mrs Jane Try until its sale and demolition for Warringah Mall Shopping Centre c.1957.

Photograph: Private collection

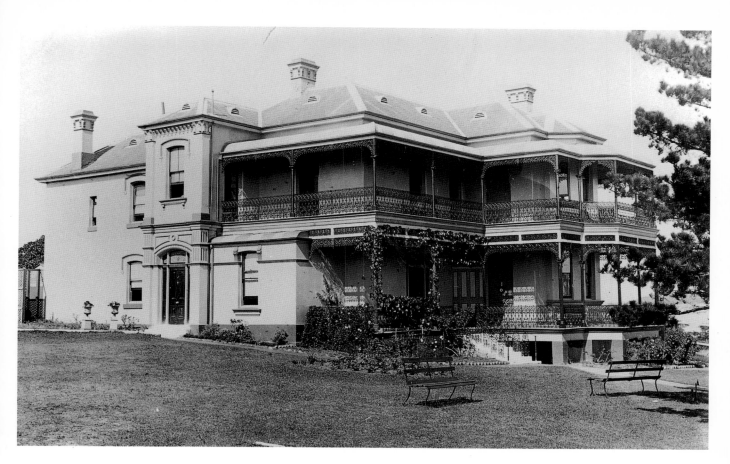

Above and left

Oyama

Addison Road, Manly

Built in the 1880s for John George Griffin, and photographed when the residence of Henry Septimus Badgery and his family (1892-1912). Subdivision of the estate commenced in the ensuing decade; the house, near present Oyama Avenue, was later demolished and flats built on the site.

Photographs: Private Collection

Bilgola House
Bilgola

Built c.1870 for the Hon. William Bede Dalley as a weekend cottage. Used later as a guest house, it was demolished for a new bungalow in 1922.

Photograph: Arthur Wigram Allen; Allen Family Albums, Mitchell Library, SLNSW

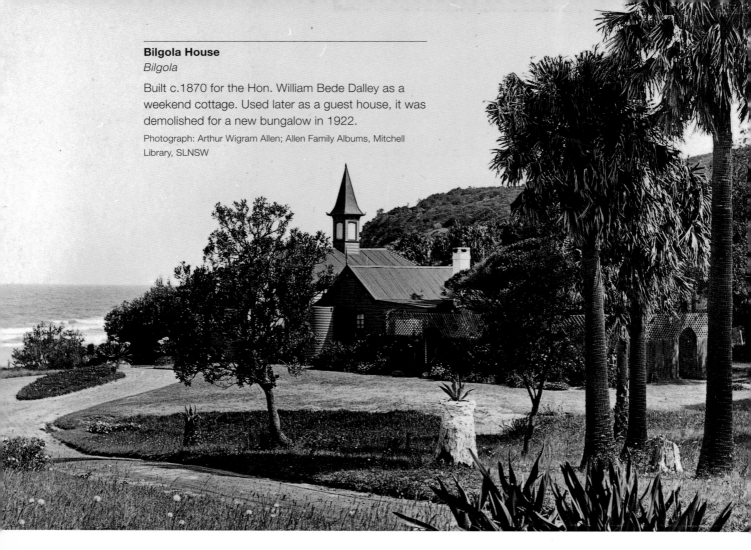

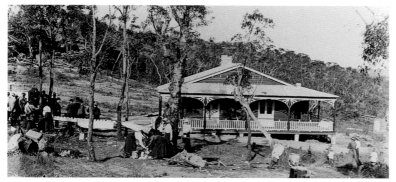

Left

Ade Marr
43 Starkey Street, Forestville

Built in 1916 by volunteers from the City Council, for Patrick Henry Lynch, a Boer War and Gallipoli veteran, the cottage was named after R.D. Meagher, Lord Mayor of Sydney. One of the cottages built on Soldier Settlement blocks at Forestville under a volunteer scheme instigated by Dr Richard Arthur, MLA. This scheme, described by Shelagh and George Champion in *Forest History* (1988), was adopted in a number of Sydney suburbs. Few of the Forestville houses survive; a c.1970s house now occupies the site of Ade Marr.

Photograph: GPO 1, Mitchell Library, SLNSW

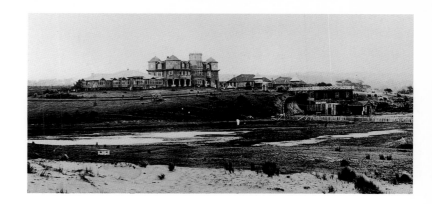

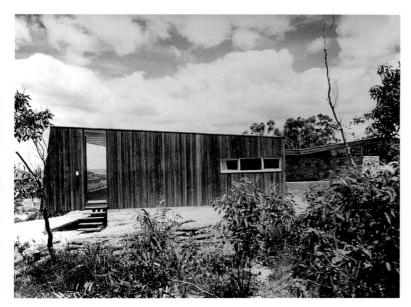

Above

La Corniche

Mona Vale

This extraordinary agglomeration of buildings built in the 1890s for George Brock, merchant, included a residence, a large private hotel and guest chalets overlooking artificial lakes and polo grounds. When the venture failed, part of the land was subdivided and sold. The complex (known locally as Brock's Folly), later taken over by Mr Rainaud and renamed La Corniche, was demolished for home units in 1958.

Photograph: Warringah Shire Library

Left and bottom left

House

Bynya Road, Whale Beach

Built in 1952 as a beach house for the Landau family, to a design by Harry Seidler, architect, the house was demolished in the 1990s for a new house.

Photograph: Max Dupain; Max Dupain & Associates

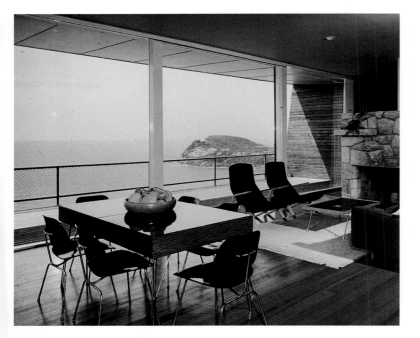

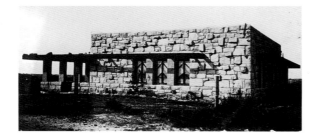

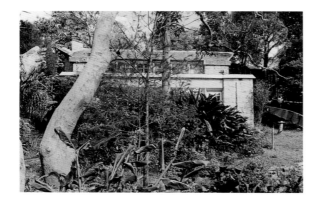

Left

House

Sortie Port and Edinburgh Road, Castlecrag

Built in 1923 to a design of Walter Burley Griffin, architect, for King O'Malley, politician. On completion it was occupied by Edgar Herbert and his family until sold in 1927 to Drs Edward and Lorna Rivett. Later Cabarisha Hospital and still in Rivett family ownership, extensions were undertaken by Griffin, and in the 1930s, by Eric Nicholls, architect. The hospital, its name changed to Castlecrag Private Hospital, was sold in 1970. Subsequent remodelling has left little of the original fabric.

Photograph: Willoughby City Library, Local Studies Collection

Left and below left

House

177 Edinburgh Road, Castlecrag

Designed and built in 1936 by sculptor Vernon Arthur (Bim) Hilder for his wife, artist Roma Hopkinson (below left), and himself. An early example of open and split-level planning, its detail displayed strong stylistic similarities to houses built in the area by Walter Burley Griffin, for whom Hilder had worked as a carpenter. Following Hilder's death, the house was sold in 1993. Despite its significance to the community and submissions made by the Hilder family, the Heritage Council resolved 'to take no action under the Heritage Act' to protect it. The house and two studios where Hilder worked on his many public sculptures were demolished in 1994.

Photographs: courtesy of Kimble Hilder

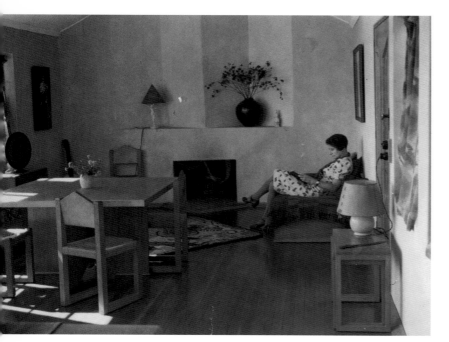

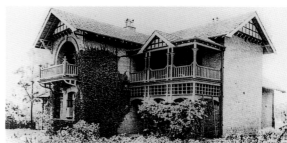

Above

Astraea

Centennial Avenue, Chatswood

Built in 1894 for J. W. R. Jenkins and later named Astraea when a girls' school 1906-1936; the house was demolished for home units in 1971.

Photograph: Willoughby City Library, Local Studies Collection

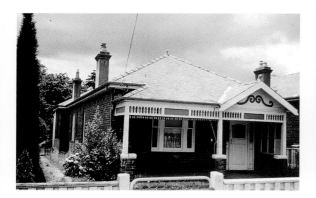

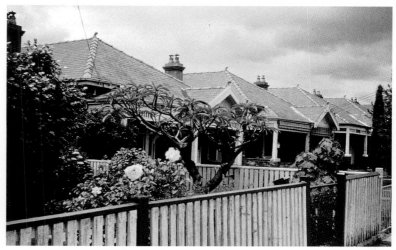

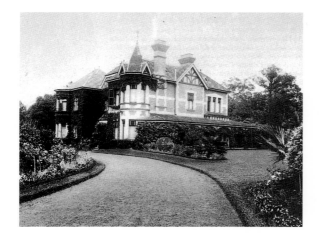

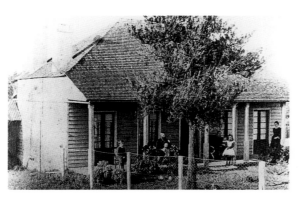

Houses

37-43 Archer Street, Chatswood

Built in 1915-16 by Joseph Spora, the middle four of this row of eight almost identical single-fronted Edwardian houses were demolished in 1988 for town houses. Recognised as an important socio-economic grouping, they had been classified by the National Trust of Australia (NSW) and listed in the local heritage survey in the early 1980s. In 1988 Willoughby Council supported a development proposal for the site and in September, upon expiry of an Interim Conservation Order, demolition proceeded.

Photographs: National Trust of Australia (NSW)

Above left

Chislehurst

Centennial Avenue, Chatswood

Built in 1892 for John de Villiers Lamb, and named Mooroombah, the house was purchased in 1906 by Edward Carr Hordern, retailer, and renamed Chislehurst. Following his death in 1940, his widow and sister remained until 1953-54 when the house was acquired by the government and demolished for Chatswood High School.

Photograph: courtesy of Lesley and Marsden Hordern

Above

Robert Pymble's House

Lane Cove Road (Pacific Highway), Pymble

Built in the 1820s for Robert Pymble on his grant of 600 acres (243 ha). The kitchen was used later as a railway ticket office. Demolished by the Department of Railways c.1890.

Photograph: Ku-ring-gai Historical Society

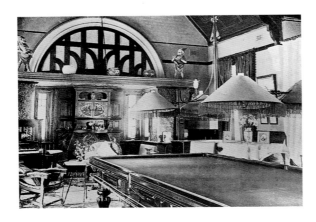

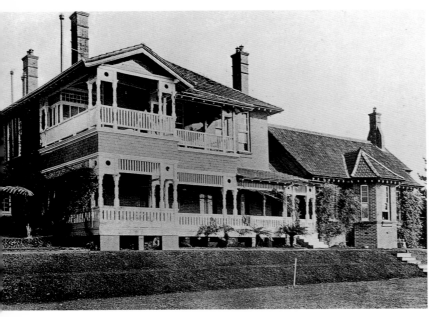

Top left and above

Cooinoo

Boyd Street and Kissing Point Road, Turramurra

Built c.1900 for W. S. Adams and by the 1920s a fashionable guesthouse. One of several large residences on the upper North Shore featured in *Our Beautiful Homes* (c.1907) that have been demolished. Home units now occupy its site.

Photographs: *Our Beautiful Homes*, c.1907

Top right

Slab cottage

Fairlawn Avenue, Turramurra

Photographed in 1899 when occupied by Bill Foster and his family, this slab cottage, built c.1850, was a late survivor of its type in the district. Since demolished.

Photograph: John Morrison Skinner; Ku-ring-gai Historical Society

Above

Breffni

37 Chilton Parade, Warrawee

Built in 1942 for Dorothy and Henry Scorer, to a design by C. Bruce Dellit, architect, it was purchased in 1950 by the Hon. Mr Justice McTiernan, a Judge of the High Court of Australia, and remained in the McTiernan family until its sale in 1997. A rare example of domestic design by Dellit, who was renowned for his public buildings in the Art Deco style. The house was demolished for a new house in 1998.

Photograph: Bradley Hankey, courtesy of Graham Brooks and Associates

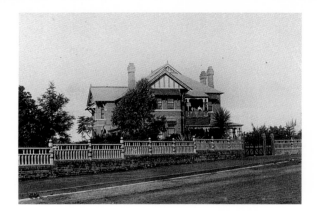

Above and right

Pakenham

George Street, Hornsby

Built in 1894 for James and Sarah Channon, its high quality materials and decorative interiors are described by Helen Barker and May Elven in their *Houses of Hornsby Shire* (1989). Converted in 1935 to a private hospital and renamed St Kilda, the house was demolished c.1960 for Westfield Shopping Plaza.

Photographs: Hornsby Shire Historical Society

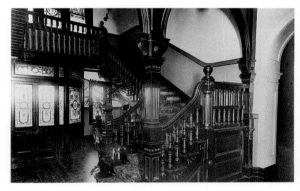

Left

Glenella, Inglebrae and Heatherlie

George Street, Hornsby

Each of Sarah and James Channon's six children received a furnished home as a wedding gift from their parents. Three of the houses were built in George Street adjacent to Pakenham between 1900 and 1910 for Effie, John and Florence Channon. All were demolished c.1960 for Westfield Shopping Plaza.

Photographs: Hornsby Shire Historical Society

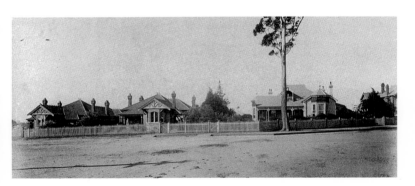

Left

Edgmond

Pacific Highway and Woonona Avenue, Wahroonga.

Built c.1898 by Slatyer and Cosh, architects, for William Cooper, and representative of the many houses in the Queen Anne-style built on the upper North Shore, it was demolished in the 1970s for home units.

Photograph: *Our Beautiful Homes*, c.1907

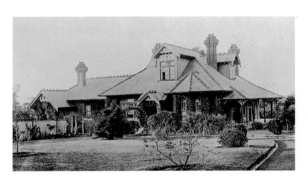

Amalfi

Kenneth Street, Longueville

Originally a single-storey sandstone cottage built c.1873 by Richard Sim, a flour miller, it was purchased in 1881 by Joseph Palmer, a sharebroker who commissioned architect Ernest A. Bonney to add a second storey and tower. The house remained in the Palmer family until its sale in 1958 when it was demolished for home units.

Photograph and information: Lane Cove Library, Local Studies Collection

Y-Berth

River and Greenwich Roads, Greenwich

A three-storey home built in the early 1880s by John St Vincent Welch as his first home in Greenwich, it was purchased c.1890 by the Society of Jesus and renamed Loyola. Subsequently purchased by the Sisters of St Joseph of Orange and renamed Stella Maris, it was demolished in 1966 and replaced by a new hostel.

Photograph and information: Lane Cove Library, Local Studies Collection

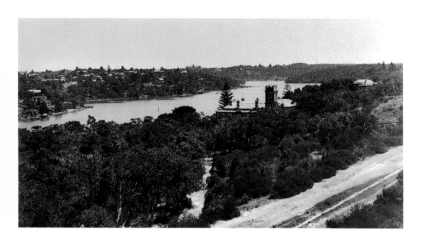

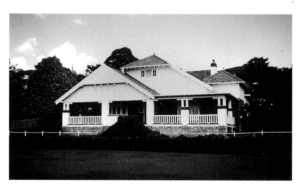

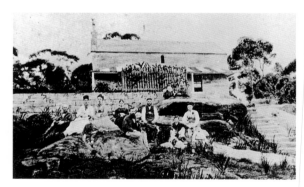

Above

Wanella

1 Stuart Street, Longueville

Built c.1916 for the Munro family and owned 1918-1985 by the Moyston family, its waterfront grounds included a croquet lawn and weatherboard teahouse. Demolished in 1986 for residential subdivision.

Photograph: Rod Howard; National Trust of Australia (NSW)

Above

Albert Cottage

Burns Bay, Lane Cove

A two-storey cottage built in 1868 by the Radke family adjacent to their tanneries in Burns Bay, Lane Cove. Pictured here in 1873 with members of the Radke and Borig families, the house was demolished in the 1980s for town houses.

Photograph: courtesy of Mr W. Radke; Lane Cove Library, Local Studies Collection

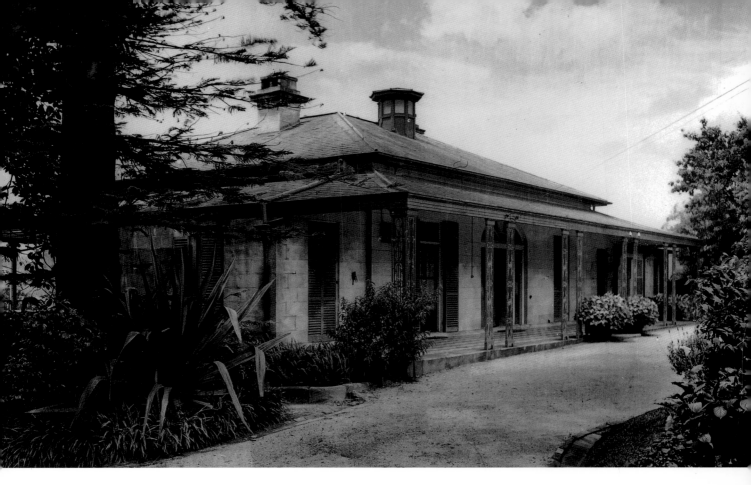

Above and Right

St Malo
Hunters Hill

Built c.1856 by Didier Joubert and remaining in family ownership for almost a century, the decorative iron columns on its entrance front were replaced in 1933 with wooden columns salvaged from the demolition of Burdekin House. Located between Reiby Road and Nemba Street, the house was demolished in 1961 for Fig Tree Bridge and its approaches. Since 1949 local residents and the National Trust had campaigned for an alternate site for the bridge. Destroyed along with St Malo were The Warren, two other Joubert houses Nemba and Reibey Cottage, irreplaceable trees and most of Avenue Road. The 1960s was a period of widespread destruction in Hunters Hill with many houses of heritage significance demolished for home units.

Photographs: Harold Cazneaux; Mitchell Library, SLNSW

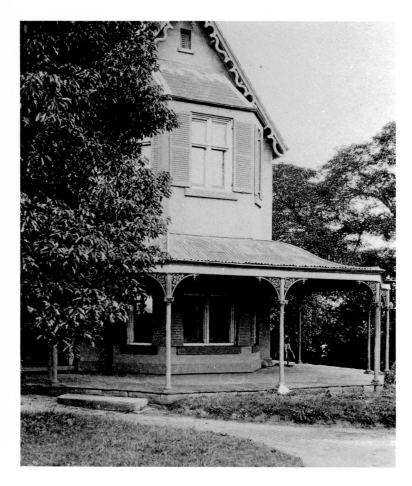

Left

Osgathorpe

Victoria Road, Gladesville

Built in 1881 for John le Gay Brereton and adjoining a stone cottage owned by him since 1860. The house which remained in family ownership until purchased by timber merchant A.E. Primrose in the 1920s. It was demolished for extensions to his timber yard in 1957.

Photograph: Royal Australian Historical Society

Below

Lauriston

Victoria Road, Ryde

Built in 1875 by James J. Shuttleworth, architect, for himself. A fine example of his work, the house was demolished for a suburban subdivision and a motel in 1959.

Photograph: SPF (BM) Mitchell Library, SLNSW

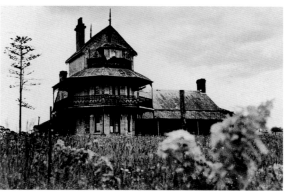

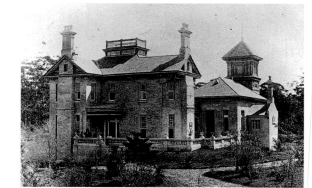

Above

Pomona

Cox's Road, Ryde

Built c.1870 for Joseph Cox, with a three-storey addition c.1880, it remained in Cox family ownership until 1952 when it was purchased and demolished by the Housing Commission of New South Wales for residential subdivision.

Photograph: Laurence le Guay; National Library of Australia

Right

Meadow Bank House

Meadowbank

Built c.1835 for Captain William Bennett and his wife Susan, the house remained in family ownership until the 1920s when the property was acquired by Ryde Council for the establishment of Meadowbank Park. The house was demolished in the 1950s.

Photograph: Royal Australian Historical Society

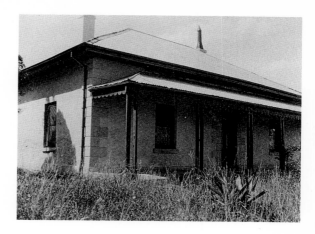

Centre

Helenie

Meadowbank

Built in 1840 for Isaac Shepherd, pastoralist and politician, it was tenanted by Henry Parkes in the 1850s. Ruinous and demolished in 1939.

Photograph: Royal Australian Historical Society

Below

Cleves

Ryde

Built in 1843 for J. B. Darvall, barrister, the house was owned by Charles Blaxland and his family from 1852 until c.1912. Located in the vicinity of present Waterview Street, between Douglas and Charles Streets, Putney, the house was demolished in the 1920s.

Photograph: Ryde City Library, Local Studies Collection

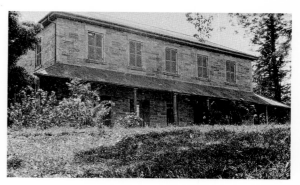

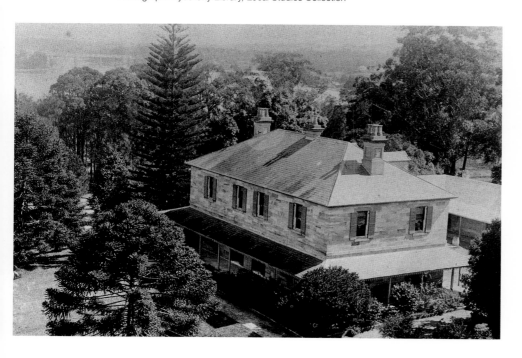

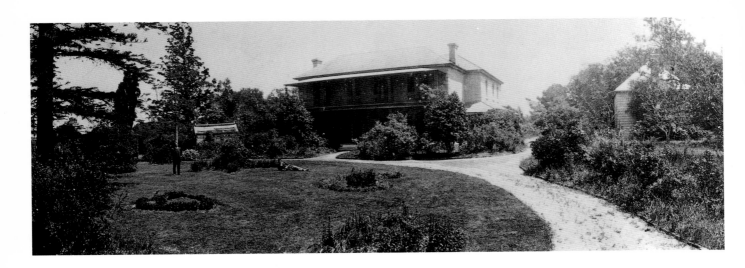

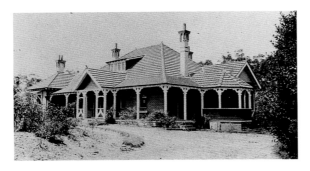

Above

Ermington Park
Ermington

Built in 1828 for Major Edmund Lockyer. After a succession of owners, it was purchased in 1876 by John Richard Linsley, politician and long-time local resident. Remaining in Linsley family ownership until its sale in 1926, the house, located in the vicinity of present Lancaster Avenue and Crowley Crescent, and whose name was adopted for the suburb was demolished for residential subdivision c.1930.

Photograph: Ryde City Library, Local Studies Collection

Centre

Oaklands
Kirkham Street and Boronia Avenue, Beecroft

Built in 1906 for the Tucker family, and set in a formal garden with large orchard at rear. Demolished for home units in 1962.

Photograph: Brian Hirst, Hornsby Shire Library

Above

Cherrybrook
West Pennant Hills

Its name later adopted for the suburb, the cottage was built by 1839 by Joseph and Mary Ann Harrison, and with later additions, remained in family ownership until the 1920s when sold and demolished. In the late 1950s part of the former farm was subdivided as Cherrybrook Gardens Estate on which thirty-five project homes were built in1959, as the Parade of Homes, promoted by the Australian Women's Weekly *Home Planning Services,* their plans and details published in a supplement to the magazine.

Photograph: courtesy Mrs Cay Carmichael

House
New Farm Road, Cherrybrook

Built in 1959 by Grimson and Rose, project builders, to a design by Harry Seidler, architect, and one of thirty-five project homes built on the Cherrybrook Estate, it was demolished in 1997. The rest of the project homes survive, relatively intact.

Photograph: by Max Dupain; Max Dupain & Associates

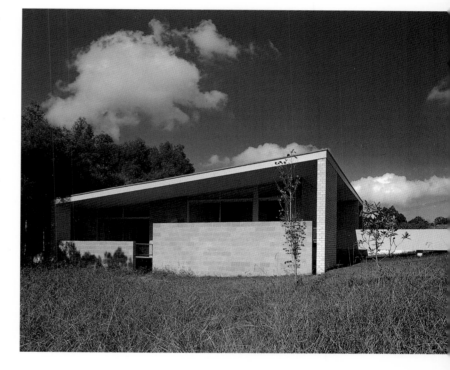

Below left

Roxburgh Hall
Windsor Road, Baulkham Hills

Built by Andrew Louis McDougall in 1858 on land granted to his forebears in 1799. The property, which had a succession of owners after 1875, was progressively subdivided; the house was demolished in 1968 for further residential subdivision.

Photograph: SPF, Mitchell Library, SLNSW

Below right

Government House
Windsor

Built in 1796 for the commanding officer of the district, with later additions. By c.1919 the house was ruinous and demolished.

Photograph: Royal Australian Historical Society

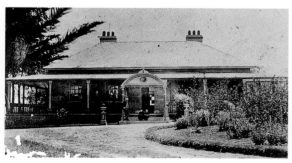

St James's Church of England Rectory

Pitt Town

Built c.1850; demolished despite local protest and replaced by a new colonial-style rectory in 1973.

Photograph: National Trust of Australia (NSW)

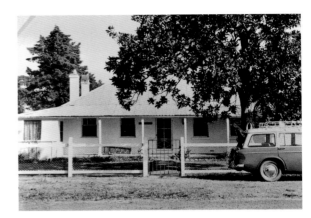

Centre

Clarendon

Windsor

An early farmhouse built by William Cox, pastoralist and road builder, it fell into disrepair and was demolished in the early 1920s. Outbuildings located in Dight Street, some distance from the house, survive.

Photograph: Frank Walker; Walker Papers, Mitchell Library, SLNSW

Below

Houses

Dight Street, Windsor

A unified streetscape of mid-nineteenth century houses progressively demolished in the 1970s by Windsor Council for a new civic centre.

Photograph: Clive Lucas; National Trust of Australia (NSW)

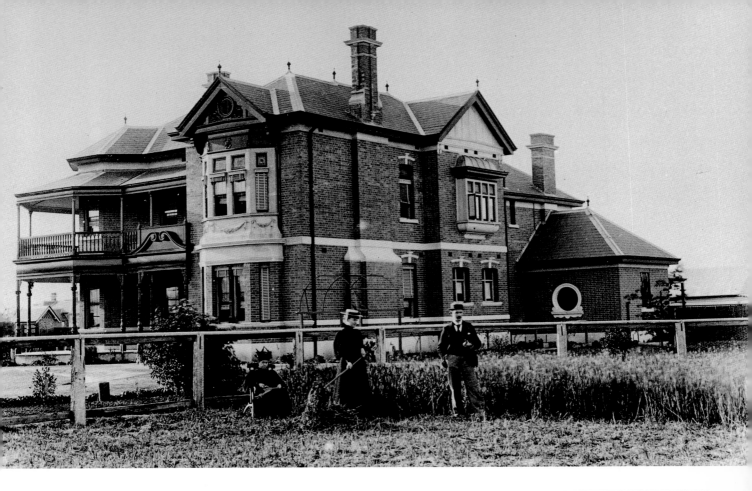

Kamilaroi

Windsor Street, Richmond

Built in 1893 for Benjamin Richards, founder of
Riverstone Meatworks. From the 1930s the house
was used as part of the Richmond Public School
complex until its demolition in 1956 by the
Department of Education for a new school building.
The front gates and posts remain.

Photograph: Hawkesbury City Library, Local Studies Collection

Right

Cottage

23 Moray Street, Richmond

Built in the 1870s for the railway gatekeeper.
Classified by the National Trust and designated of
significance in the local heritage survey, this cottage
was put to sale by tender in 1987, sold and
demolished. Its twin at the Bourke Street crossing
was demolished, despite strong local protest, in
1985.

Photograph: National Trust of Australia (NSW)

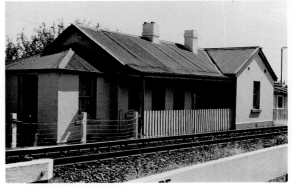

INDEX

ABBREVIATIONS

GPO 1 Government Printing Office Videodisc 1
SLNSW State Library of New South Wales
SPF Small Pictures File
SPF(BM) Small Pictures Files (Basement)

SOURCES

Information on houses featured in this publication has been
compiled mainly from the large range of published local histories,
from local studies collections at local government libraries and from
the files of the National Trust of Australia (NSW). Biographical
information on a substantial number of the owners and tenants can
be found in the *Australian Dictionary of Biography* held in most local
libraries and H. J. Gibbney and A. G. Smith (eds) *A Biographical
Register*, Canberra, 1987. Research files for individual houses have
been deposited in the Historic Houses Trust's Resource Centre, 61
Darghan Street, Glebe which is open to the public by appointment.
Telephone 02 9692 8366.

ACKNOWLEDGEMENTS

This book and the accompanying exhibition have been made possible through the encouragement, knowledge, generosity and patience of many people and organisations. Foremost are the authors of the essays: Shirley Fitzgerald and David Marr who shared in the enthusiasm for the project and the rage for what has gone and Brian Preston who has guided the reader through the maze of heritage and planning legislation, and colleagues James Broadbent, whose 1988 exhibition Demolished Houses of New South Wales, has contributed in many ways to this publication and Elizabeth Ellis whose valuable advice helped to establish its format.

Three institutions have been the major sources of photographs. To them and to their staff I owe a debt of gratitude for following up numerous enquiries for photographs and permitting their reproduction: Mari Metzke and Kylie Rees, Royal Australian Historical Society; Ian Stephenson, Mara Barnes, Julie Blyth and Elsa Atkin, National Trust of Australia (NSW); Alan Ventress, Mitchell Librarian and Alan Davies, Jennifer Broomhead, Christine Pryke, Helen Harrison and Mark Hildebrand of the Mitchell and Dixson Libraries, State Library of New South Wales.

For generously sharing their local knowledge and providing information and photographs of houses I am grateful to Terry Kass; Christopher Pratten; Nora Peek; Shylie and Ken Brown; Carol Liston; John McClymont; Ruth Daniell; Zeny Edwards; Bruce Baskerville; Lesley Muir and Brian Madden; Peter Reynolds; Daphne Kingston; Donna Braye, Marrickville Library Services; Judy Washington, Lane Cove Library; Margaret Park and Leonie Masson, North Sydney Council; John Johnson, Rockdale City Library; Megan Martin, Catriona Quinn, Linda Rector and Sally Webster, Resource Centre, Historic Houses Trust of NSW.

For lending and allowing the reproduction of photographs, for supplying information and in lending objects, I am indebted to Henry Badgery; Douglass Baglin; Graham Brooks and Associates; Chris Bluett, Woollahra Council; Business Land Group; Cay Carmichael; David Chalk; Shelagh and George Champion; Bill Chapman; Douglas Gilling; Alex Goodsell, Campbelltown and Airds Historical Society; Judy Guerin; Jenni and Kimble Hilder; Graham Hinton, Fairfield Regional Heritage Centre; Aileen and Harold Holden; Lesley and Marsden Hordern; Hornsby Shire Historical Society; Marianne Ilbery; Ian Jack; Adrienne Kabos, Walter Burley Griffin Society; Grace Karskens; Candice le Guay; Macleay Museum; Helen Malcher, Ku-ring-gai Historical Society; W.A.J. Maston; Robert Moore; Judith O'Callaghan and Anne Watson, Museum of Applied Arts and Sciences; Dr John Phillips; Charles Pickett; Penelope Pike; Helen Proudfoot; Diana Ritchie; Liz Roveen; Harry Seidler; Eric Sierins, Max Dupain and Associates; State Records Authority; Sydney Church of England Girls Grammar School (SCEGGS) and Janet Howse; Gil Wahlquist and Diana Drake, Hunters Hill Trust; Meredith Walker; James Whitelock; Ken Woolley and Gloria Meyer, Ancher Mortlock and Woolley; Mr Bertram Wright; John Wrigley.

The following local government authorities have permitted reproduction of their photographs; their local studies librarians and archivists have given generously of their time and knowledge: Auburn: Edmund Perrin; Campbelltown: Georgina Keep; Canterbury: Catherine Hardie; Hawkesbury: Michelle Nichols; Hornsby: Sue Johnston; Hurstville: Margaret Murphy and Gaye Pracy; Ku-ring-gai: Jennifer Sloggett; Randwick: Niall Pettit-Young, Bowen Library, Maroubra; Ryde: Jennifer MacDonald; Sutherland: Helen McDonald; Sydney: Mark Stevens; Warringah Library; Willoughby: Carol Russell; Woollahra: Jane Britten.

I wish to thank staff of the Historic Houses Trust for their interest and assistance: Caroline Butler-Bowdon, Sheridan Burke, Dayn Cooper, Rebecca Haagsma, Jane Kelso, Caroline Lorentz, Caroline Mackaness, Cassandra Morgan, Kate Murray, Karen Rudd and Helen Weston.

To Peter Tonkin for his splendid exhibition design; to Richard Taylor, exhibitions officer, for skilfully overseeing its production with extraordinary attention to detail; and to Bruce Smythe, for his excellent book design, I owe an especial debt of gratitude, not only for the way they have applied their talents, but for their patience, courtesy and good humour.

Joy Hughes

CONTRIBUTORS

Shirley Fitzgerald is the City Historian for the council of the City of Sydney. She does not live in an old house.

David Marr is a Sydney journalist who wrote the biographies of Garfield Barwick and Patrick White.

Brian J Preston is a barrister with expertise in environmental and planning law and a lecturer in law (part-time) at the University of Sydney in the post-graduate environmental law programme.

Joy Hughes is a historian with a special interest in local history and the built environment.

PUBLICATION AND EXHIBITION TEAM

Curator/Editor
 Joy Hughes
Exhibition Design
 Peter Tonkin Design
Exhibition Officer
 Richard Taylor
Collections Management
 Caroline Lorentz
Exhibition Assistants
 Kate Murray, Karen Rudd
Senior Display Planner
 Bruce Smythe
Production assistance
 Karen McKenzie, Caroline Tung
Exhibitions Coordinator
 Caroline Mackaness

DISCLAIMER

Published by
Historic Houses Trust
of New South Wales

a statutory authority which manages important properties and house museums in New South Wales for the education and enjoyment of the public.
Enquiries 02 9692 8366

Elizabeth Bay House
Elizabeth Farm
Government House
Hyde Park Barracks Museum
Justice & Police Museum
Lyndhurst
Meroogal
Museum of Sydney
on the site of first Government House
Rose Seidler House
Rouse Hill estate
Susannah Place
The Mint
Vaucluse House

This book was published on the occasion of the exhibition
Demolished Houses of Sydney
17 April to 26 September 1999
Greenway Gallery
Hyde Park Barracks Museum
Queens Square
Macquarie Street Sydney
Telephone 02 9223 8922

Designed by Bruce Smythe
Printed in Australia
by Bloxham & Chambers

© 1999 Historic Houses Trust
of New South Wales, Glebe, NSW
ISBN 0 949753 81 5

Cover: Lowe house, Mosman Bay, designed by Harry Seidler, architect, 1951. Demolished in the mid-1990s. Photograph Max Dupain

Back cover: The Rangers, Mosman, built in 1844 by John Hilly, architect, for Oswald Bloxhame. Demolished 1912. Photograph Mitchell Library, SLNSW